LONDON'S RIVER
WESTMINSTER TO WOOLWICH

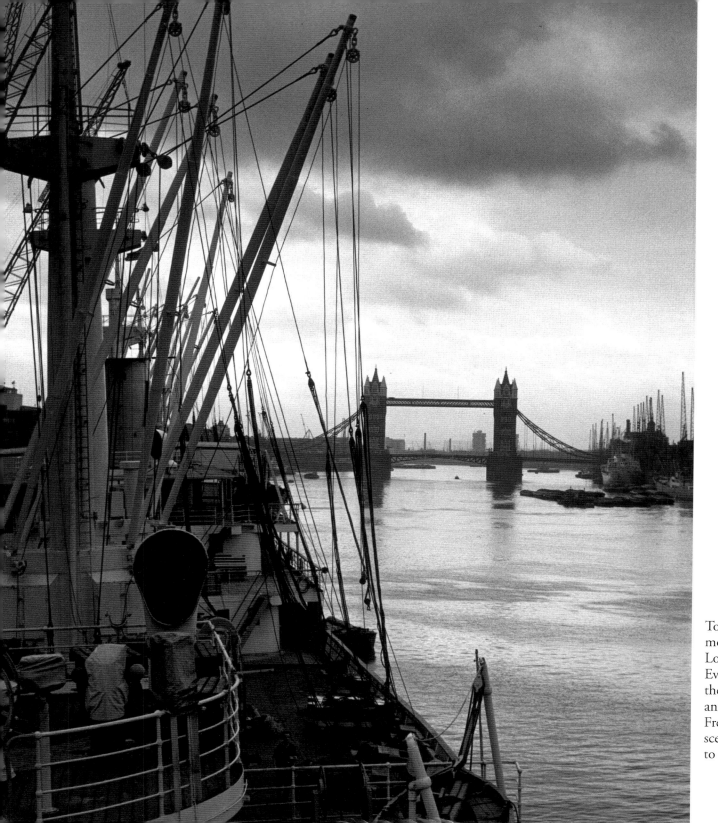

Tower Bridge and part of a moored ship seen from London Bridge, 1964. Everything within this view – the mood on the river, cranes and the moored ship by New Fresh Wharf – recalls a river scene which has long ceased to exist.

LONDON'S RIVER
WESTMINSTER TO WOOLWICH

CHRIS THURMAN

TEMPUS

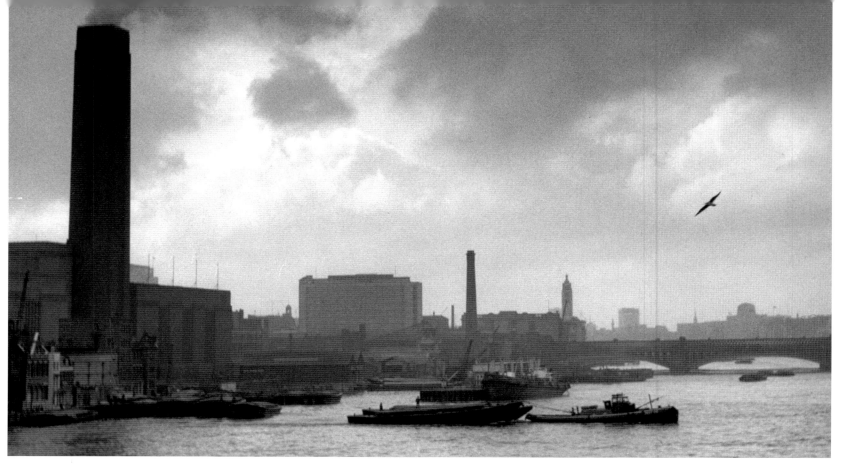

This view of Bankside Power Station taken in 1964 depicts a bygone
view of the river. Today tugs are rarely seen, the Oxo Tower is lost
among high-rise buildings and the Bankside Power Station has been
converted to the highly successful Tate Modern Art Gallery.

First published 2002
This edition 2003

British Library Cataloguing in Publication Data.
A catalogue record for this book is available from the British Library.

ISBN 0 7524 2595 1

Typesetting and origination by Tempus Publishing.
Printed in Great Britain by Midway Colour Print, Wiltshire.

CONTENTS

THAMES ESTUARY

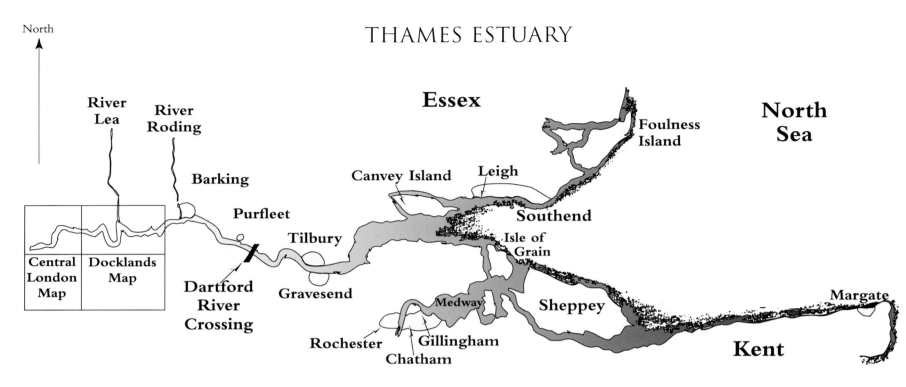

The Thames Estuary showing the stretch of the river from Central London to the sea. The areas contained within the two rectangles are shown in greater detail in subsequent sketch maps. From London, the river flows past the Docklands, the downstream port of Tilbury and then into the North Sea between Essex and Kent where it forms the natural boundary between the two counties. One place visible just outside the Docklands area, on the north bank, is Barking, where the author lived for many years. This map also shows a number of other towns and locations that are mentioned at various places in the text. The whole of this part of the river is tidal.

ACKNOWLEDGEMENTS

Firstly to Gill, for her support and for joining me on the many walks around London as I tried to establish where photographs had been taken as well as to take the 'now' shots. To those friends who were supportive after learning of the idea for this book, and to Campbell McCutcheon of Tempus Publishing for his advice during the preparation of this book, which, for me, was a totally new project, and to congratulate Emma Jackson, also of Tempus, for her splendid design work. Last, but not least, to Bob Aspinall, the Librarian at the new Museum in Docklands, who thought that my photographs were of historical interest and encouraged me to seek a publisher.

INTRODUCTION

I was given my first good camera as a Christmas present when I lived in Barking, which is a short journey from London on the District Line of London's Underground system. And so it was inevitable that as a new, young, keen photographer I took many photographs of the major tourist sights of London. My first photographs of the river, and the buildings beside the river, were taken in 1956, while still at school. I continued to photograph the river while continuing my studies in London and during the time I worked in the City in the mid-1960s. I should add that photography has always been a hobby albeit one I have taken very seriously and I became an Associate of the Royal Photographic Society some twenty years ago.

Many years later I realised that my photographs had recorded a scene which had changed considerably; that in effect I had been taking photographs at the end of an era of many centuries. More specifically, while researching information for this book it became clear that my photographs of the Upper Pool taken in the 1950s and 1960s were really scenes from the Victorian times. And so I then decided to start taking 'now' photographs to complement the 'then' photographs already in my archive. In preparing the 'artwork' for this book, I have printed negatives for the first time in over forty years, and at a much larger size than ever before.

Over the past forty-plus years there have been massive economic and social changes and some of these changes can be seen in the photographs in this essay. Rather than repeatedly referring to these changes in the captions to the photographs, I thought that it would be helpful to draw out some of the main themes that emerge.

THE DECLINE OF THE DOCKS

The docks and warehouses on the River Thames extended downstream from Blackfriars Bridge on the north bank, and from Bankside on the south bank. As seen in the photographs in the early chapters of this study, the great nineteenth-century buildings still existed upstream from Tower Bridge during the 1950s and 1960s.

There had been quays in London from the Roman times, and a 40ft Roman quay has recently been discovered near Custom House by Lower Thames Street, while the quays at Billingsgate and Queenhithe had been recorded well before AD 1000. The first enclosed wet docks were at Blackwall (later called Brunswick) and Howland Great Dock. It was not until the early nineteenth century that the enclosed docks were constructed between Tower Bridge and Gallions Reach. One of the features of these docks was their high walls, which stemmed from the West India Dock Act of 1799 and were related to the requirements of the tax collectors who wanted to make sure that they collected the right amounts of import duties and excise revenues.

During the nineteenth century new docks were built at regular intervals, reflecting the increased trade between Britain and the rest of the world. This was due to at least two underlying causes – the fact that Britain led the world in industrial innovation following the Industrial Revolution, and the continuous increase in population imposing ever-greater needs for imported food. A brief chronology of the openings and subsequent closures of those docks featured in this essay (plus a few others on the northern side) follows:

Name of Dock	Year Opened	Year Closed
West India	1802	1980
London	1805	1969
East India	1807	1967
St Katherine's	1828	1968
West India South	1829	1980
Royal Victoria	1855	1981
Millwall	1868	1980
Royal Albert	1880	1981
King George V	1921	1981

The one other relevant development was the construction of the Tilbury docks in 1886, at a distance 26 miles down river from Tower Bridge. Tilbury docks subsequently came under the control of the Port of London Authority following its formation in 1909.

London was the UK's number one port at the time when the first photographs in this essay were taken. The situation basically remained unchanged until the 1960s when the docks suffered a sudden downturn in trade, which led pretty quickly to their closure. For instance, all docks were fully active, even those above Tower Bridge (as shown in this photo-study) in 1965, but in 1981, the Royal Group was the last of the London upstream docks to close. Why did this happen?

A number of different reasons have been given although it is outside the scope of this study to try to assess their relative importance. Among the reasons are:

The End of the Empire
On the face of it this seems to be an odd reason as the UK is still a major trading nation exporting a higher proportion of its GDP than most advanced economies. However, the nature of that trade has changed and a significant proportion of the UK's trade today is with the other members of the European Union. Commercial vehicles, using the ferries and Channel Tunnel, carry a large proportion of the UK's imports and exports.

Labour Troubles

Tardy modernisation of dock facilities
In particular, competition from foreign ports, especially Rotterdam, which had invested heavily in modern cargo handling facilities and were able to berth the largest vessels.

Increases in the size of ships
Larger ships, and their ability to carry containers, meant that they were more economic for the transport of freight. However, such ships were unable to use the upper reaches of the Thames and it was important that their operations were not constrained by waiting for tides before either berthing or starting a new journey. Only Tilbury was able to offer these facilities and it now has the only operational docks in the Port of London.

THE DECLINE OF OTHER INDUSTRIAL ACTIVITY

While the decline of the docks is the most visible aspect of the industrial change that has affected the Thames waterfront in Central London, other related industrial activities were also affected, such as ship repair (although not featured in this sequence of photographs). However, it is not just the docks that have witnessed economic change. Three examples in this essay are Bankside and Battersea power stations and the Courage Brewery.

ARTS BESIDE THE THAMES

At the time of the earliest photographs, the only Arts building that bordered the river was the Royal Festival Hall, which had been opened in 1951 as part of the Festival of Britain. Since then, the South Bank Arts Complex has been developed even though this meant demolishing the Shot Tower, which had played such a unusual role in the 1951 Festival (acting as a lighthouse).

Two more recent changes have been the construction of the Globe Theatre and then, as a Millennium Year project, the conversion of Bankside Power Station into the Tate Modern Art Gallery. The new Millennium Bridge is designed to give a pedestrian link from the northern side of the river to the Globe Theatre and Tate Modern.

LEISURE ON THE THAMES

In the mid-1950s there was little leisure use of the river; there is one photograph which shows the 'beach' in front of the Tower of London, and people sitting on it. The *Royal Sovereign* was a notable attraction carrying people from Tower Pier to Southend Pier (the longest in the country) and on to Margate.

The position has now changed considerably. Two of the docks have become marinas, namely St Katherine's Dock and the Regent Canal Dock, which is now called the Limehouse Marina. In addition, there is other related activity, for instance, 'The Little Ship Club' is featured in one photograph. The other change has been the large number of vessels undertaking sightseeing trips for visitors to London, and these can be seen in many photographs.

RIVERSIDE PUBS

Riverside pubs have always been a feature of Thames-side life. For most of the time these pubs were simply serving the local people, although some of them have had a very long history. However, in recent times the scene has changed considerably. Some pubs have been developed to meet the needs of the new population in areas such as the Docklands, for instance the transformation of a Dockmaster's House into the Barley Mow pub in Limehouse. Other pubs have been built to meet the needs of the tourist, such as along the South Bank between Tower Bridge and Waterloo Bridge, for example, the Founders Arms.

GROWTH OF TOURISM

There is little evidence of tourism in the early photographs in this study; indeed there are two views taken in the vicinity of the Tower of London which contain a remarkable lack of people.

Tourism has become a major industry in its own right. Its growth has been one of the most important changes of the past four decades and there are so many different examples of it in this photo-essay such as The Tower Hotel, HMS *Belfast* and Hay's Galleria, with its shops and restaurants.

CHANGES IN RESIDENTIAL ACCOMMODATION

There are at least three major developments since the mid 1950s that are visible in many photographs:

 The construction of high-rise blocks of flats (tower blocks)
 The re-development of the riverside warehouses into
 upmarket apartments
 The construction of new apartment buildings beside the river

The construction of the tower blocks can be seen in the comparison shots of a boat passing under Cannon Street railway bridge. These blocks are in Southwark, which is not surprising as much of the area south of the river, even in the heart of London, is residential. At one time these tower blocks were thought to be the answer to London's housing problem, but this opinion has now completely changed and they are seen as creating their own set of social problems.

On the other hand, living by the river in upmarket flats has become very fashionable. The external walls of many warehouses, and even a brewery, have been retained while the inside of the building has been gutted and turned into luxurious apartments. There are many locations where these luxury redevelopments are almost side by side with the old council (publicly owned) property, with a huge gap in incomes between those living in the redeveloped warehouses and those living in the old council property. Many of these converted warehouses appear in the photographs, particularly in the chapter concerned with Wapping and Limehouse.

THE CONSTRUCTION OF OFFICE BUILDINGS

The best known developments are the high-rise buildings, such as the NatWest Tower and the Canary Wharf Tower, but as seen in this set of photographs there are many new offices fronting the river where once there were warehouses and docks. The period covered by these photographs includes several different building booms, notably in the 1980s and 1990s.

However, these booms were not without their problems. Plans for the NatWest Tower were made in the early 1960s but building did not commence until 1971 as they had to be revised in order to meet the needs of the local planning authorities including the preservation of listed buildings. The redevelopment of the Canary Wharf area was affected when the company which had built the Canary Wharf Tower, Olympia and York, went into liquidation in 1992.

DEVELOPMENT OF NEW TRANSPORT FACILITIES

The whole redevelopment of the Docklands area led to the need for a better transport infrastructure. One notable development has been the construction of the Docklands Light Railway. These trains are automatically controlled – there is no driver – and appear in several photographs.

There have also been other changes. One example has been the change in Upper and Lower Thames Street from a narrow road winding between warehouses to a major thoroughfare from the Tower of London to the Victoria Embankment and beyond.

ST PAUL'S WAS ONCE THE TALLEST BUILDING

When the first photographs in this study were taken, St Paul's Cathedral was the tallest building in London and this had been the case since its construction in 1710. This situation was to remain unchanged for 250 years when, following the emergence of new building techniques, St Paul's Cathedral lost its pre-eminent position with the topping out of the Millbank Tower in 1961. Since then many new tower blocks have appeared, although some of the older buildings (St Paul's in particular) can still dominate the skyline when photographed from certain angles.

Some of the taller buildings (height in feet) seen in this essay are:

Canary Wharf	812
British Telecom Tower	620
NatWest Tower	600
Millennium Wheel	450
Millbank Tower	387
St Paul's Cathedral	385
Shell Building	350 ?
Battersea Power Station	300
St Bride's Church	230
Monument	202
'Big Ben' Clock tower of the Houses of Parliament	150
Cannon Street Station towers	110

(Excludes the two new towers at Canary Wharf)

THE BRIDGES

The stretch of the River Thames between Tower Bridge and Westminster Bridge covers the commercial centre of London, the City, the political centre of the UK, at Westminster, as well as many of the major tourist-sights. It also includes the Upper Pool of London, which used to be the farthest inland section of the Thames that ocean-going ships were docked. The following table lists the bridges that are included within this essay together with other relevant data:

Name of Bridge	Date completed	Engineer/architect/designer
Tower Bridge	1894	Sir Horace Jones and John Wolfe Barry
London Bridge		
nineteenth-century structure	1831	John Rennie
current structure	1972	Lord Holford – builders were Mott, Hay and Anderson
Cannon Street railway bridge	1866	John Hawkshaw and John Wolfe-Barry
Southwark Bridge		
first structure	1819	John Rennie
current structure	1921	Sir Ernest George – builders were Mott and Hay
Millennium Footbridge	2000	Although due to open in 2000 this was put back due to technical factors, but is now fully operational. Designed by Lord Foster

Name of Bridge	Date completed	Engineer/architect/designer
Blackfriars Bridge		
first structure	1769	Robert Mylne
current structure	1869	Joseph Cubitt and H. Carr
Waterloo Bridge		
first structure	1817	John Rennie
current structure	1942	Sir Giles Gilbert Scott
Hungerford railway bridge		
first structure	1845	Isambard Kingdom Brunel
current structure	1864	Sir John Hawkshaw
Westminster Bridge		
first structure	1750	Charles Labelye
current structure	1862	Sir Charles Barry
Lambeth Bridge		
first structure	1862	P.W. Barlow
current structure	1932	Sir George Humphreys

The bridges between the Tower and Westminster were photographed during the 1950s and 1960s and were mainly Victorian or earlier. Exceptions are Southwark Bridge (1921) and Waterloo Bridge (1942).

The table confirms that there were two quite hectic periods when new bridges were under construction. The first period involved John Rennie, with London Bridge (1831), Southwark Bridge (1819) and Waterloo Bridge (1817) as well as Vauxhall Bridge (1816). The second period came some thirty years later with Cannon Street railway bridge (1866), Blackfriars Bridge (1869), Hungerford railway bridge (1864), Westminster Bridge (1862), and Lambeth Bridge (1862). Remarkably, there was another gap of some thirty years before the opening of the final Victorian structure, Tower Bridge.

CONCLUSION

Changes are inevitable in any city, but perhaps the one conclusion that can be drawn from this study is that over the past forty years or so the rate of change has speeded up. However, such a discussion is for others, and not for this documentary photographer.

SOURCES

Many different sources were used in compiling the information given in the captions such as different atlases including a street plan of London published in the 1930s and articles from the Financial Times relating to modern buildings. The most used books were the London Encyclopaedia (Weinreb & Hibbert, Macmillan), London's Lost Riverscape (Ellmers & Werner, Guild Publishing) and two books on the Docklands by Dr S.K. al Naib (North East London Polytechnic). The programme to the 1951 South Bank Exhibition was another useful source of information.

Chris Thurman, MBE
August 2003

CENTRAL LONDON

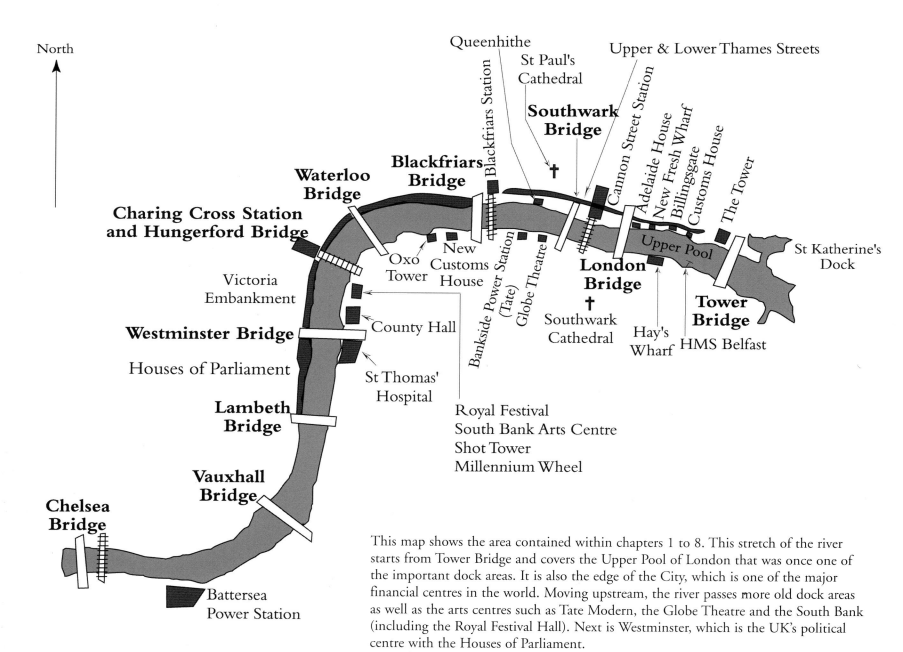

North

Queenhithe

St Paul's Cathedral

Upper & Lower Thames Streets

Blackfriars Station

Southwark Bridge

Cannon Street Station

Adelaide House

New Fresh Wharf

Billingsgate

Customs House

The Tower

Blackfriars Bridge

Waterloo Bridge

Charing Cross Station and Hungerford Bridge

Oxo Tower

New Customs House

Bankside Power Station (Tate)

Globe Theatre

London Bridge

Upper Pool

St Katherine's Dock

Victoria Embankment

County Hall

Southwark Cathedral

Tower Bridge

Westminster Bridge

Houses of Parliament

St Thomas' Hospital

Hay's Wharf

HMS Belfast

Lambeth Bridge

Royal Festival
South Bank Arts Centre
Shot Tower
Millennium Wheel

Vauxhall Bridge

Chelsea Bridge

Battersea Power Station

This map shows the area contained within chapters 1 to 8. This stretch of the river starts from Tower Bridge and covers the Upper Pool of London that was once one of the important dock areas. It is also the edge of the City, which is one of the major financial centres in the world. Moving upstream, the river passes more old dock areas as well as the arts centres such as Tate Modern, the Globe Theatre and the South Bank (including the Royal Festival Hall). Next is Westminster, which is the UK's political centre with the Houses of Parliament.

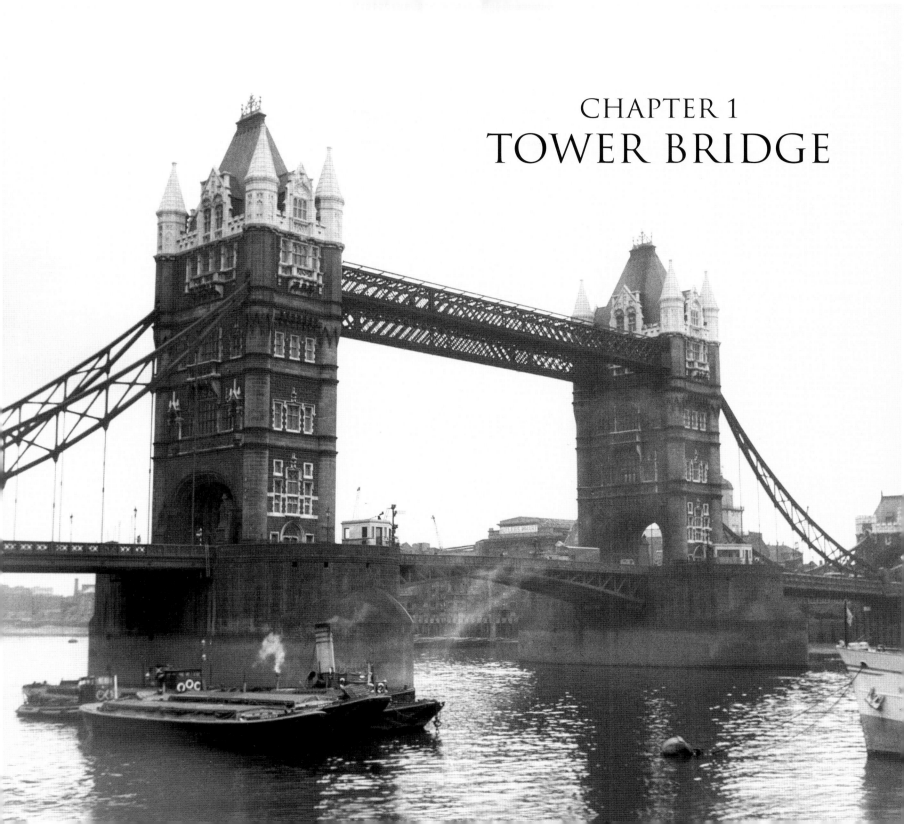

CHAPTER 1
TOWER BRIDGE

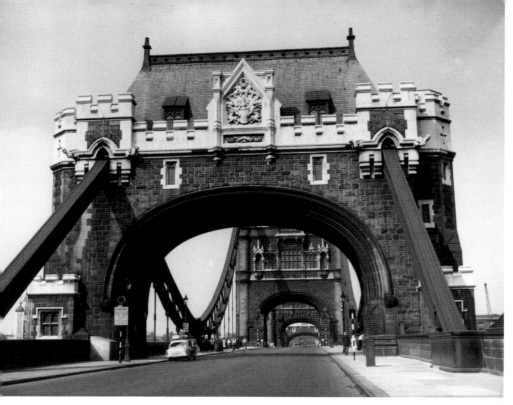

Previous page: The photograph of Tower Bridge was taken in 1956 from a viewpoint beside the Tower of London, while Butler's Wharf can be seen on the other side of the river. The tugs in the foreground were once a very common sight on the river.

While several tunnels under the river had been constructed during the nineteenth century, Tower Bridge was the first bridge (coming from the sea) across the Thames until the construction, almost a century later, of the Queen Elizabeth II Bridge at Dartford. Indeed, until the opening of Tower Bridge in 1894 the first bridge had always been London Bridge. The design of Tower Bridge is best described as 'Victorian Gothic' and it came to represent the dividing line between the Lower and Upper Pools of London.

The two towers of the bridge are made of steel and stone, and these needed to be strong enough in order to take the weight of the bascules. A bascule bridge is a type of draw-bridge that is raised and lowered by using counterweights. At first the bridge was worked by hydraulic machinery, but since the 1970s this has been replaced by electrification.

Above: This is the road entrance to the bridge from the north side of the river. The photograph was taken during the summer school holiday in 1959, and the most remarkable aspect is the almost total absence of traffic, double yellow lines and 'no parking' and 'no waiting' signs. There are only a few people about and a car is actually parked on the bridge, a quiet scene unknown to today's commuters and tourists.

Right: Tower Bridge in 1965. Ships can be seen moored at Butler's Wharf on the far side of the river, and the white tower of the Courage Brewery is clearly visible to the right of the Bridge. There are still barges everywhere on the river.

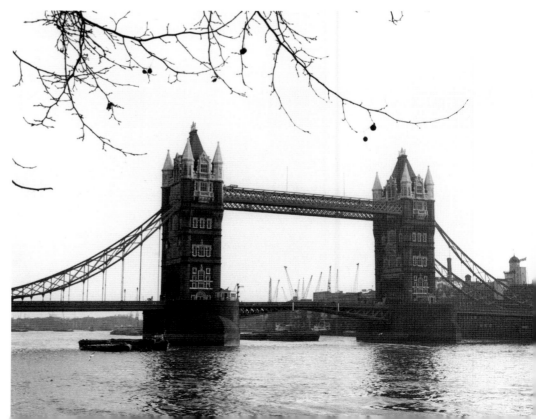

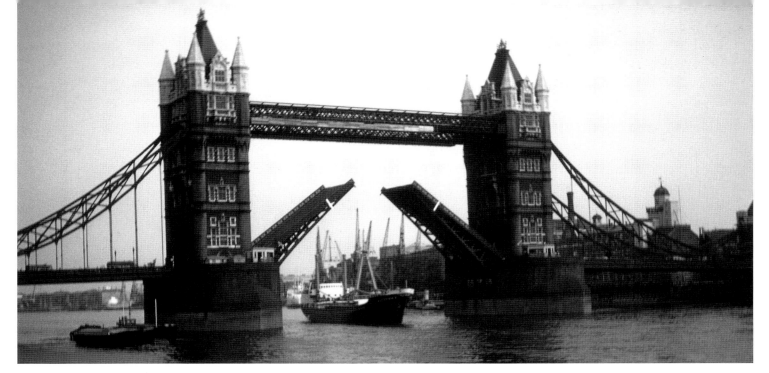

These two photographs, taken in the late 1960s, show the bridge raised and a cargo ship passing underneath. Two criteria regarding the bridge's design were that the opening span should be 200ft and that there should be a headroom of 135ft. The ship, *Batavier V*, was owned by the Batavia line. Their steamers made regular crossings between Rotterdam and the quay in front of Customs House, carrying general cargo.

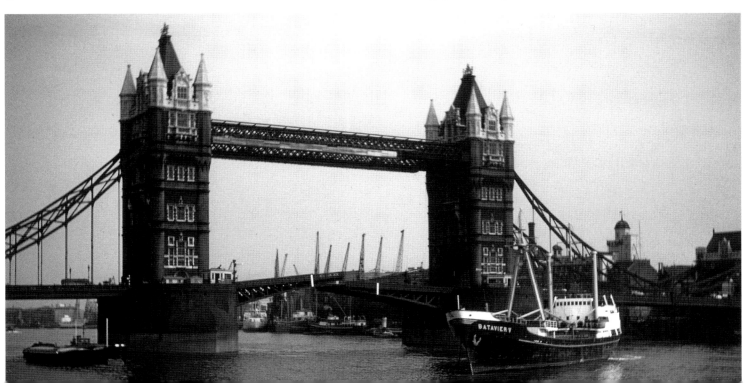

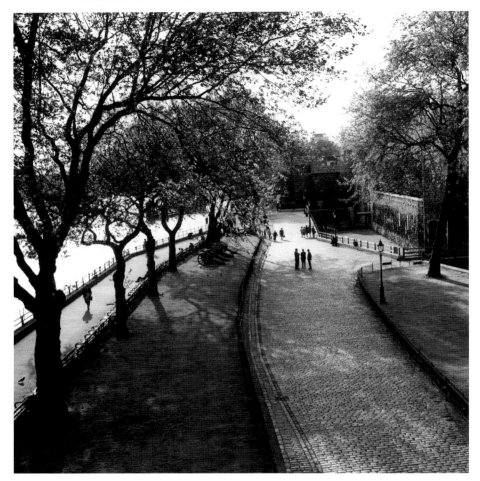

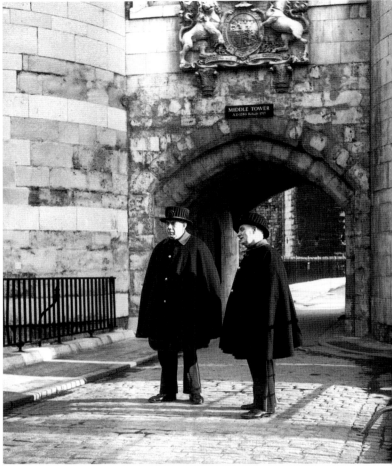

Above: This cobbled path lies between the river and the exterior walls of the Tower of London. This photograph was taken one late Saturday afternoon during the early summer of 1965. It was clearly a fine summer's day, and yet the path is almost deserted; a complete contrast with the tourists that nowadays crowd into this area.

Above right: Beefeaters, 1965, wearing their winter Tudor uniform. Their full title is the Yeomen Warders of the Tower of London, and they were founded by the Tudor monarch, Edward VI, who reigned from 1547 to 1553.

Right: A view taken in 1956 showing a barge aground and people playing on the 'beach' in front of the Tower. Using the 'beach' like this was once a common sight.

Right: Royal Sovereign and PLA building, 1956. The white ship is the *Royal Sovereign* and this undertook day trips from Tower Pier, to Southend Pier and then across the Thames Estuary to Margate. The author remembers a trip on this ship during 1948 and can be precise about the date as the ship's tannoy was relaying details of Bradman's last cricket test match.

The tall building on the right was the headquarters of the PLA (Port of London Authority). The PLA building was designed by Sir Edwin Cooper and opened in 1922; it was sold in 1971 reflecting the decline of the docks. In 1956 the PLA building was one of the highest in the City.

The PLA was established by a 1908 Act of Parliament and the passage of the Bill through the Commons was undertaken by Winston Churchill, who was President of the Board of Trade. The PLA took over full control of the docks in 1909 and its authority extended from the Nore in the Thames Estuary to Teddington, which meant it covered the whole tidal stretch of the river – about 70 miles in total. London had been the world's largest port for over 200 years, and PLA was established to ensure that this position continued by overseeing aspects of dock management. Its remit also included the docks at Tilbury.

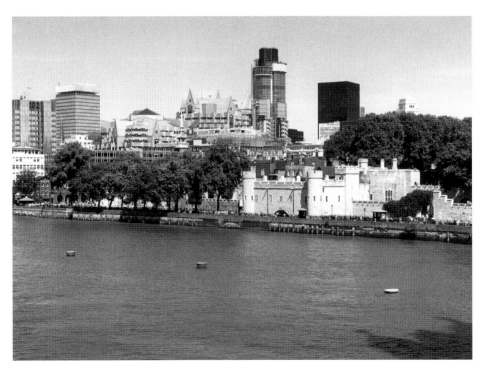

Left: This photograph is directly comparable to that above, and was taken nearly forty years later, in 1995. The two views were taken from Tower Bridge and many changes are immediately obvious. Further comparisons of the northern side of the river can be seen in subsequent photographs and the following comments apply to these forthcoming views as well. Some of the changes over time are:

The trees in the Tower grounds have grown so that the PLA building is only just visible.

The PLA building is no longer the highest around. It has now been dwarfed by several other high-rise buildings, most notably the NatWest Tower.

The old Victorian warehouses have been demolished and in their place are large modern office blocks.

The old office blocks have been demolished and replaced by modern high-rise buildings.

Trees have been removed from in front of the external walls of the Tower and the external walls have been cleaned.

In 1956 three church spires are visible on the horizon – while the churches remain their spires are completely dwarfed by the surrounding buildings.

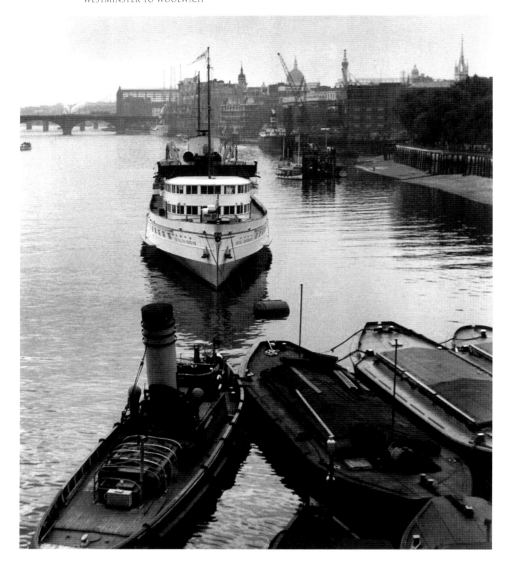

Left: Royal Sovereign and view up river, 1956. This view includes many buildings seen in later photographs – London Bridge (the next bridge up river), the tall open structure of Cannon Street railway station (smoke can be seen rising from two steam trains on Cannon Street railway bridge) and St Paul's Cathedral and the Monument on the skyline.

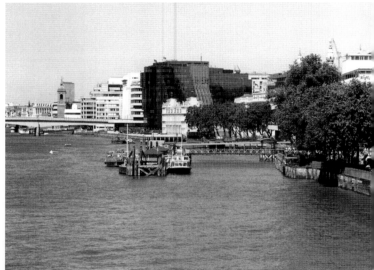

Right above: Cannon Street station and new buildings, 1995.

Right below: Continuation of riverfront showing St Paul's and the Monument, 1995. While the left-hand photo shows a basically Victorian waterfront, the other two shots on this page show how this had completely changed over the intervening forty years with modern office blocks taking the place of the Victorian warehouses.

Two views up river from Tower Bridge, 1999.

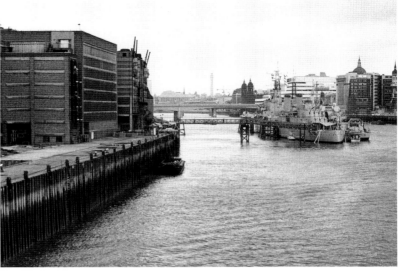

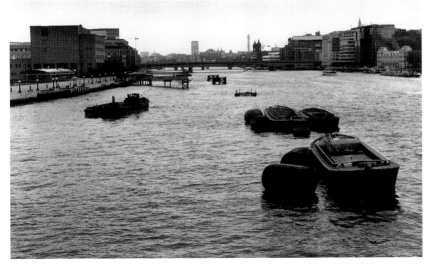

Above: HMS *Belfast* and the south bank of the river, from Tower Bridge, 1976. At one time this scene was full of warehouses, cranes and ships moored by the dockside (see first photograph of next chapter). By 1976 the busy docks had closed, HMS *Belfast* had already been moored as a tourist sight and most of the large cranes had disappeared. This scene is in effect an intermediate stage in the redevelopment of this side of the river. St Paul's Cathedral and British Telecom Tower are visible on the horizon.

The view in the above photograph should be contrasted with the other two photographs on this page, which were taken from almost the same viewpoint. The lower one shows many new buildings on both sides of the river. The small white building to the right on the 1999 view is (or used to be) Billingsgate Fish Market.

The upper photograph shows that St Paul's Cathedral and the Monument are still visible on the horizon, but large tower blocks dominate to the left of the scene. However, part of the area covered by the old warehouses is now an open park, although the gap beyond the park is to be filled by the new City Hall designed by Lord Foster.

In the 1999 views HMS *Belfast* was temporarily absent from its moorings.

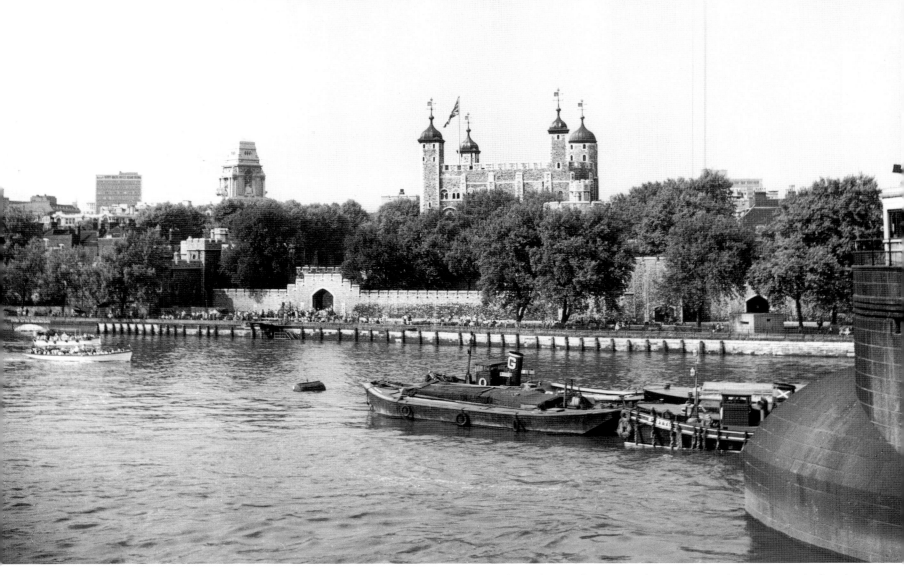

The Tower of London and the PLA building, 1959. The Tower of London is a complete medieval fortress and was started by William the Conqueror shortly after the battle of Hastings in 1066. Subsequent kings have added to the building. The most noticeable feature in these photographs is the White Tower. It was the keep, built around the beginning of the twelfth century, and it became known as the White Tower after Henry III decreed it to be white-washed in 1240.

The next two photographs show basically the same view, in 1976 and 1995. By 1976, the NatWest Tower was under construction.

The full title was the National Westminster Tower, named after the bank of that name. The building work commenced in 1971 and following a temporary suspension in 1974, it was completed in 1980. Its height of 600ft meant that it was not only the tallest building in London, but also for a short time the tallest in Europe. It has now been superseded as the tallest building by the Canary Wharf Tower in the Docklands. Following an IRA bomb in the early 1990s, the NatWest Tower was damaged and evacuated by the bank. It is now called Tower 42, but continues to be identified in this essay as the NatWest Tower.

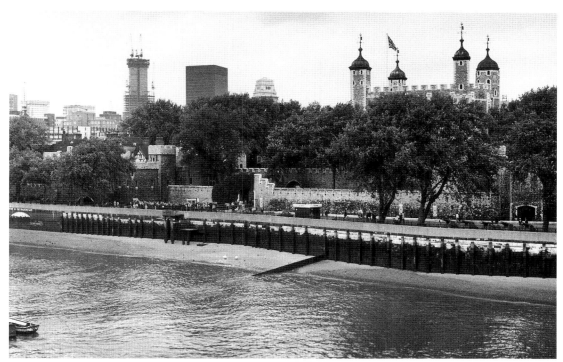

Tower of London and NatWest Tower under construction, 1976.

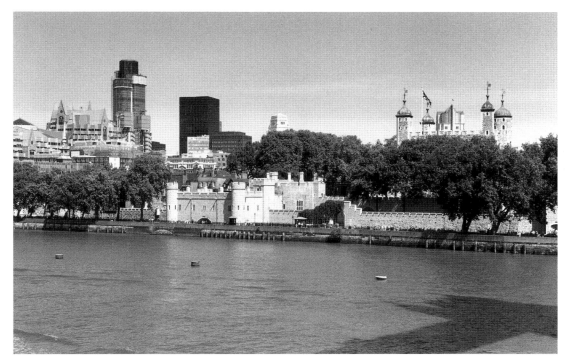

Tower of London and the completed NatWest Tower, 1995. The changes over a period of forty years in the London skyline and the external walls of the Tower of London are again evident in this photograph.

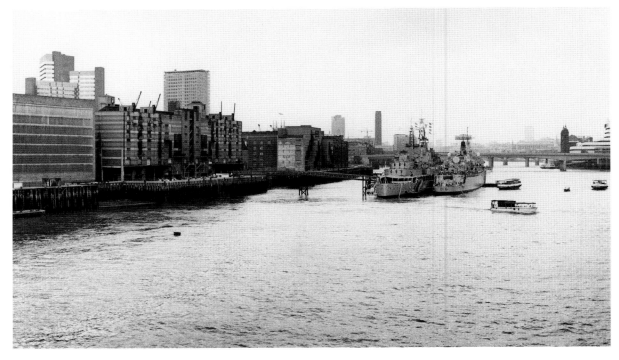

Right: South Bank from Tower Bridge, 1976.

Below: South Bank from similar viewpoint from Tower Bridge, 1995.

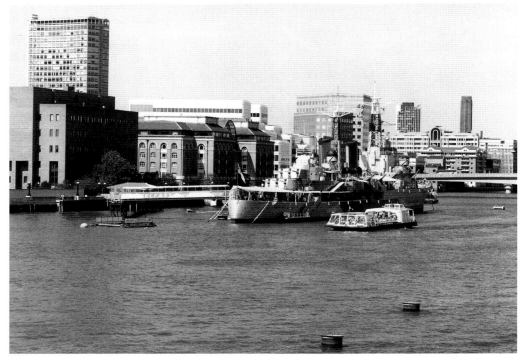

Opposite page: A classic view of the Upper Pool taken from London Bridge in 1964 showing how it once was and had been for several centuries. A ship is moored by New Fresh Wharf, four ships are moored beside the wharves on the southern bank, a barge is working its way down river. This is a busy, bustling river. But this isn't some time in the remote past. It was taken in 1964 – when the sixties were starting to swing, almost twenty years after the end of the War.

The photo shows the same bank as the two photographs on this page. In 1964 it was full of docks and warehouses, by 1976 it was in decay and HMS *Belfast* was moored and by 1995 the massive re-development was complete. Many centuries of intense dockland activity ended in a matter of a few years.

The photographs in the next chapter look at this stretch of the river as it was at the end of the 1950s and at the subsequent redevelopment. One aspect of the rebuilding can be seen in the lower photograph on this page – this is the high arch over the entrance to Hay's Galleria.

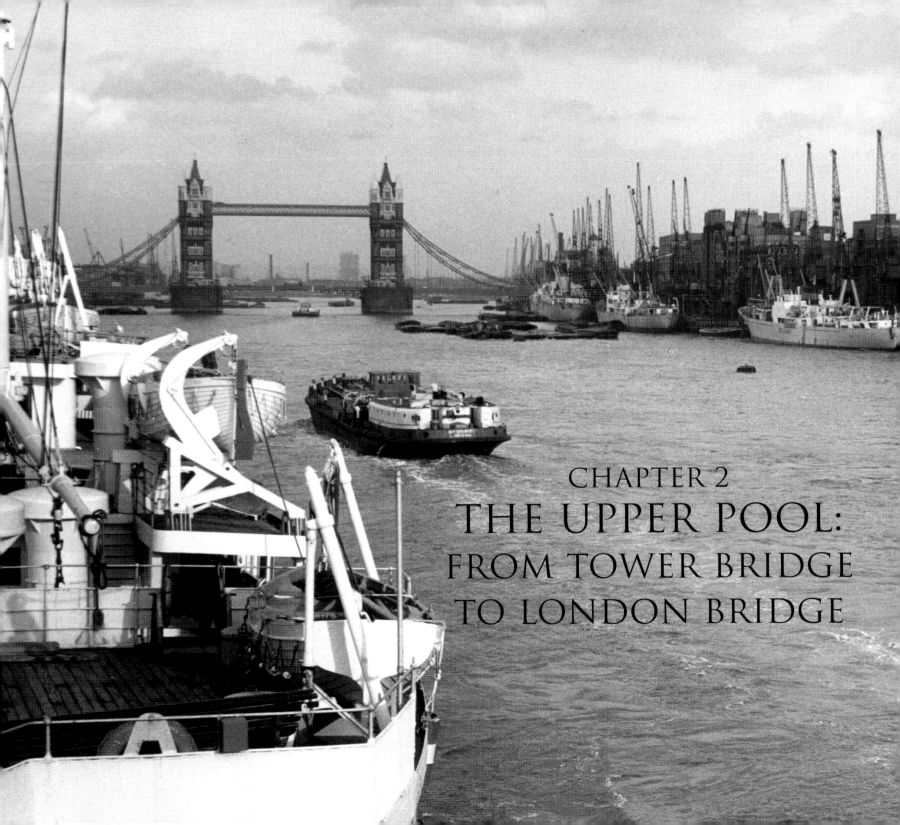

CHAPTER 2
THE UPPER POOL:
FROM TOWER BRIDGE
TO LONDON BRIDGE

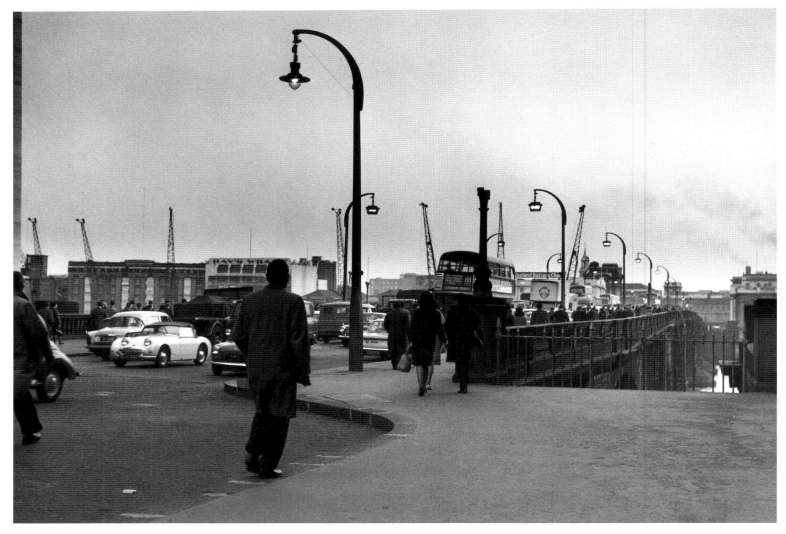

London Bridge to the south side at dusk, 1964. There has been a bridge at about this part of the river since Roman times, and this view shows John Rennie's bridge which was built in the period 1823 to 1831. This bridge appears in the photographs taken during the 1950s and 1960s. With the construction of the current bridge, Rennie's bridge was sold to entrepreneurs who re-erected it as a tourist attraction at Lake Havasu City in Arizona.

The lower photograph opposite shows the same bank thirty-eight years later and is the second (and current) London Bridge to appear in this photo-essay. This bridge is of three spans of pre-stressed concrete cantilevers and was built during the period 1967 to 1972. The builders were Mott, Hay & Anderson and Lord Holford was their architectural adviser. Pictures of this bridge appear in the more recent photographs, particularly those taken during the 1990s.

The two photographs opposite begin to show the scale of re-development that has occurred over more than three decades. Instead of wharves, warehouses and cranes there are now large modern office blocks. Only one original building remains – the offices of Hay's wharf. This building was opened in 1928, and was designed by H.S. Goodhart-Rendel in a 'distinctive continental-modern' style.

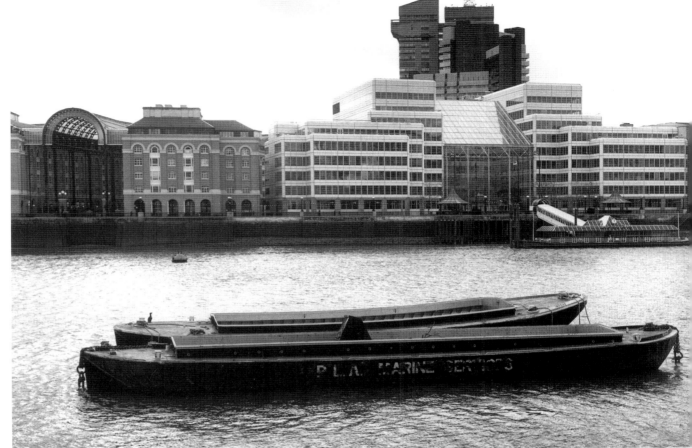

Hay's Galleria is on the left of this view of the southern bank of the Upper Pool, taken in 2002. This view, and that below, should be contrasted with the scene shown in the first photograph of this chapter, showing the change from warehouses and cranes to modern offices. It is interesting to note that the barge nearest the camera has the words 'PLA Marine Services' on its side.

A continuation of the view in the above photograph showing more new offices and then on the right the new London Bridge.

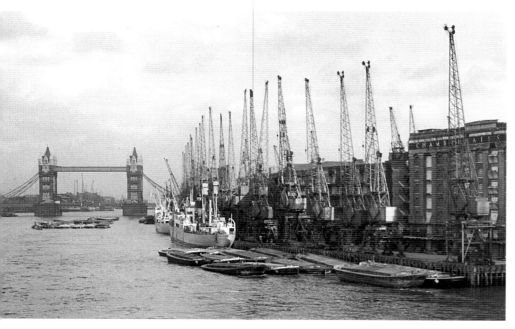

Tower Bridge, Chamberlain's Wharf and Hay's Wharf, 1964. Chamberlain's Wharf was a Victorian building, having been constructed in the 1860s. It continued in operation until 1969. The cranes have gone, but the external structure of the building remains and is now part of the London Bridge Hospital

Hay's Wharf was named after Alexander Hay, who began the wharf in 1651, and was one of the oldest in the Port of London. Its buildings appear in several photographs and stretched from Tower Bridge to London Bridge. Some of the buildings were constructed in the middle of the nineteenth century.

The lower left photograph was taken from about the same spot on London Bridge and shows yet again the changes in the river frontage. The arch over the entrance to Hay's Galleria is clearly visible – this is one of the most striking developments and is the subject of a photograph on the next page.

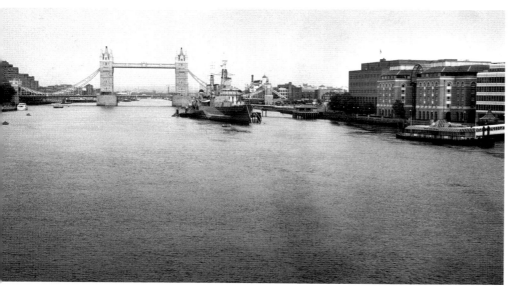

HMS *Belfast*, Tower Bridge and Hay's Galleria, 2001. HMS *Belfast* was opened to the public in 1971, a clear indicator of when the docks in this stretch of water had ceased to operate. A cruiser, she was built in 1939 and saw action in the Second World War. She has a displacement of 11,000 tons.

A hydrofoil in front of the cranes and warehouses of Hay's and Chamberlain's wharves, 1964.

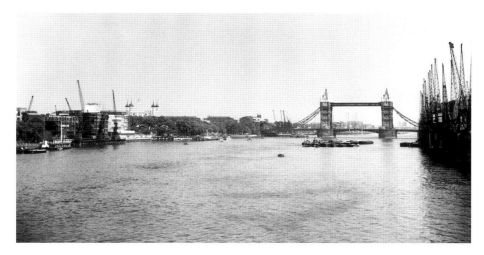

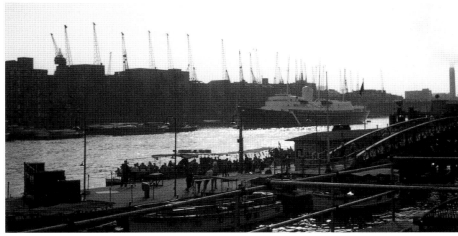

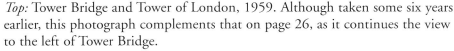

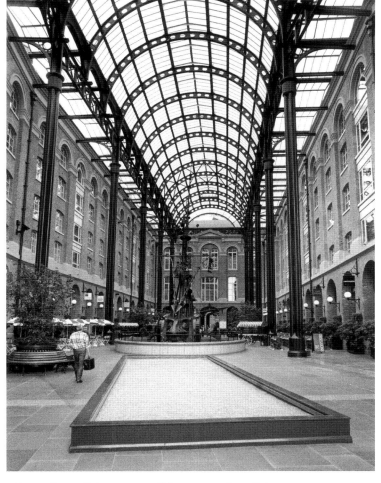

Top: Tower Bridge and Tower of London, 1959. Although taken some six years earlier, this photograph complements that on page 26, as it continues the view to the left of Tower Bridge.

Moving from left to right, the scene starts with a warehouse owned by W.H. Muller & Co. (London) Ltd, the White Tower, the buildings of St Katherine's Dock and the cranes of Irongate Wharf. The cranes seen through the towers of the bridge belong to the Foreign and British Wharf.

Bottom: HMS *Britannia*, the Royal Yacht, at anchor beside Hay's Wharf, 1960. The Yacht came into the Upper Pool at the time of the wedding of Princess Margaret and Anthony Armstrong Jones (as he then was).

Above: One of the most striking examples of the redevelopment of the Hay's wharf has been the construction of Hay's Galleria, which is shown here. Quite simply the central area was a dock – until just a couple of decades before the photograph was taken it was full of water since when it has been drained and covered. The external structures of the warehouses, built in the 1850s by W. Snooke & H. Stock, remain. The walls of the buildings on each side, and to the rear of the gallery are original; everything else is new – the paved slabs on the ground, the glass canopy and the tall steel columns. Today, Hay's Galleria is full of small shops and restaurants – very much in keeping with the tourist nature of this part of London.

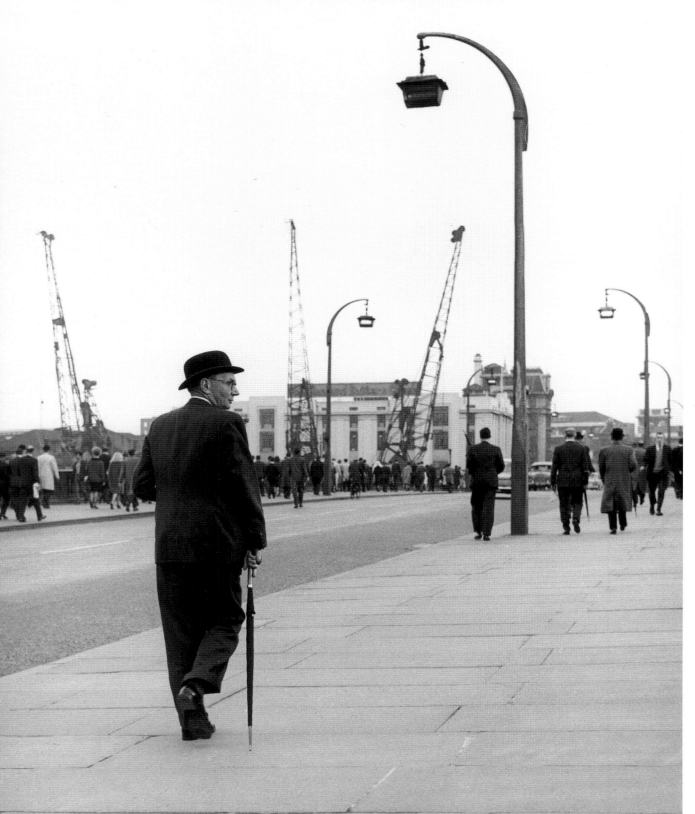

Left: Bowler-hatted commuter making his way home across Rennie's London Bridge, 1964.

Opposite: A group of commuters in front of Adelaide House heading southwards towards London Bridge 1964. Commuters were (and still are) an integral part of the London work scene and these two shots show the variety of clothes styles of that period. At one time the bowler hat and rolled umbrella were an integral part of the 'City uniform'.

Adelaide House was built in the 1920s and designed by architects Sir John Burnet and Tait. The building remains in existence today. While one side of Adelaide House opens onto London Bridge Road, its southern aspect faces the river and is seen, or referred to, several times in subsequent photographs.

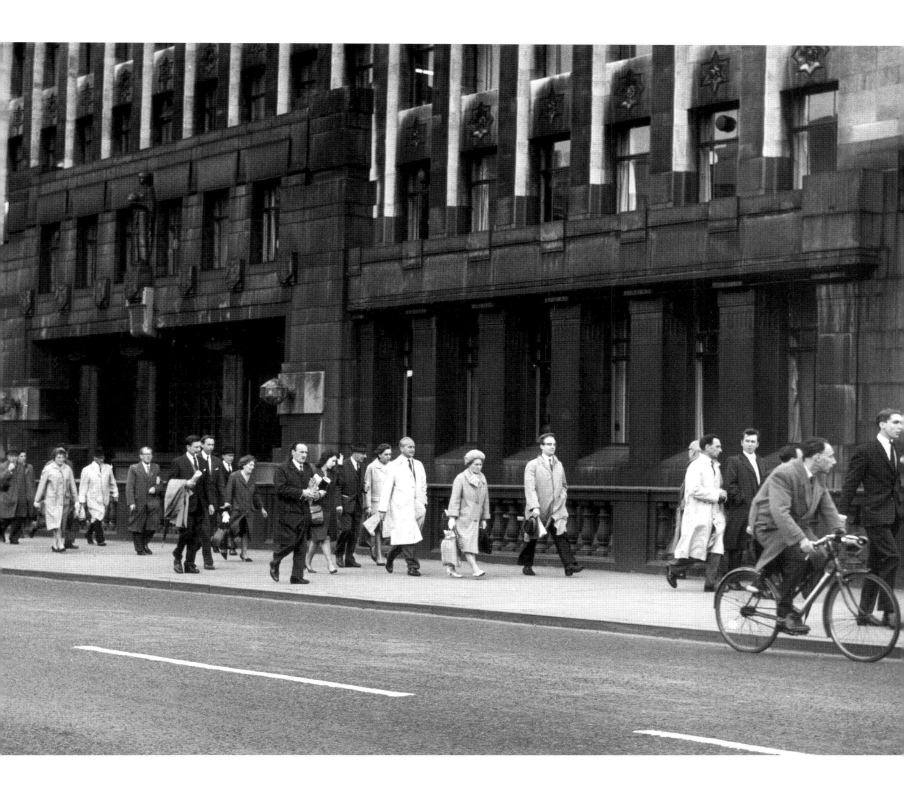

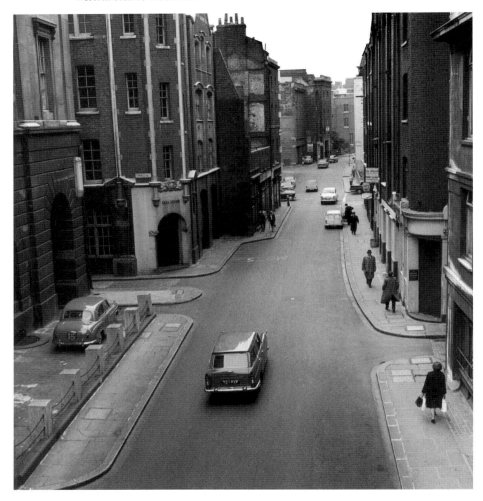

Upper Thames Street, seen from London Bridge Road, 1964. It was then a very narrow road, with lots of warehouses and offices and not a yellow line in sight. At one time this road was simply called 'Thames Street'. Nowadays, there are two roads: Upper and Lower Thames Streets, that join under London Bridge. Upper Thames Street goes from London Bridge, past Southwark Bridge to Blackfriars Bridge, while Lower Thames Street goes down river from London Bridge towards the Tower. Nowadays, the two Thames Streets are one of the major routes across London, linking East London and the City to Westminster and West London.

Upper Thames Street, 1999. This view was taken from precisely the same spot as in the photograph above left (albeit with a wide-angle lens because of the size of the buildings) and demonstrates dramatically the changes that have occurred over the past thirty years. In place of the warehouses are huge modern office blocks and instead of a narrow lane there is a modern double carriageway. The roadway is so wide that it is able to carry large commercial vehicles as well as commuter and tourist coaches.

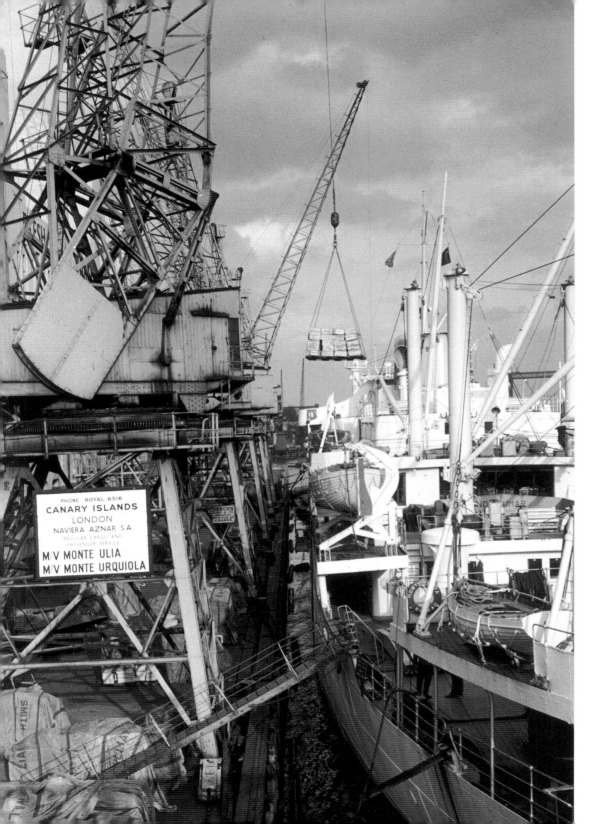

On the sign in the image:

PHONE ROYAL 6516
CANARY ISLANDS
LONDON
NAVIERA AZNAR S A
REGULAR CARGO AND
PASSENGER SERVICE
M/V MONTE ULIA
M/V MONTE URQUIOLA

Previous page: Ship moored beside New Fresh Wharf, 1964. There had been a Fresh Wharf here since medieval times, and it became a legal quay in 1559. It occupied the river frontage from London Bridge and in front of Adelaide House, as well as the quays in front of the wharf itself. It is clear that the buildings seen in these photographs are of post-war construction. However, they have now been demolished and replaced by office blocks, as can be seen in a later photograph in this chapter.

This wharf and its cranes are also featured in the photograph on this page which shows a cargo ship being unloaded. The notice confirms that the wharf was used by ships owned (or operated) by Naviera Aznar SA, which provided a regular passenger and cargo service between London and the Canary Islands. The *Monte Ulia* had a gross displacement of over 10,000 tons.

Left: Ship unloading by New Fresh Wharf, 1964.

Opposite: Car park in front of Adelaide House, 1964. The dark building to the left is Adelaide House, while the white building just visible to the right is New Fresh Wharf. This photograph clearly confirms how the wharf-side activities extended to areas beyond the actual warehouse. The cars are themselves interesting, comprising a Ford Anglia, a Mini and a Rover P4.

This car park still existed in 1995 as the lower photograph on page 34 confirms. Also evident is the new office block which has taken the place of the New Fresh Wharf (see overleaf). However, even this photograph is slightly dated as there is now (2003) a riverside path which reduces the size of the car park.

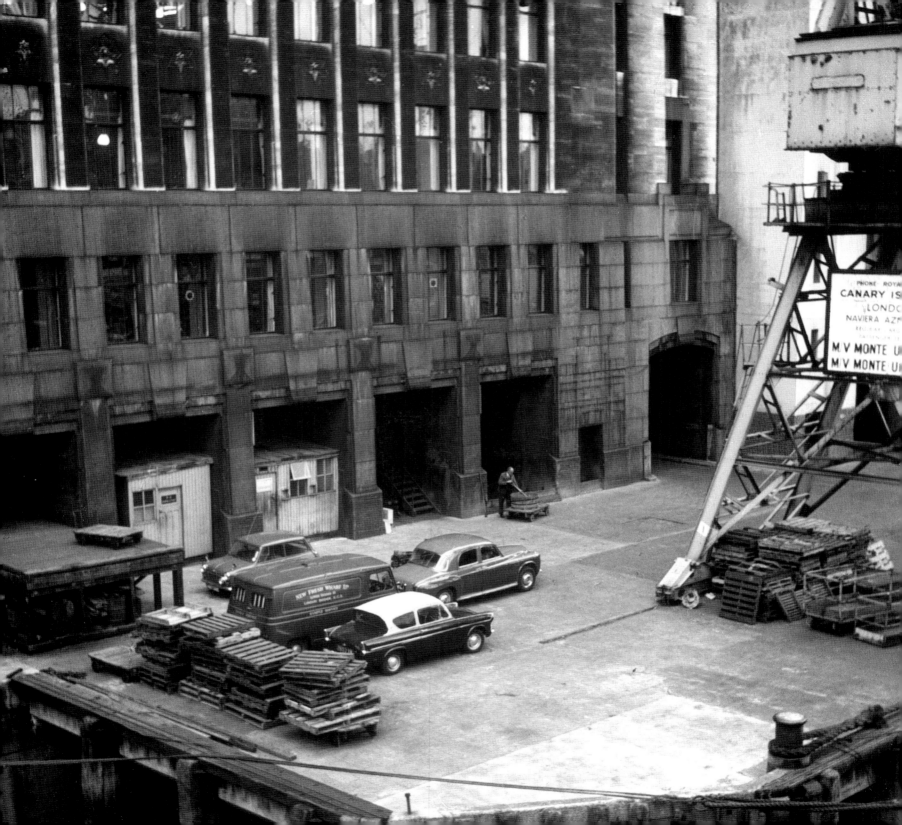

Opposite top: New Fresh Wharf to Customs House, 1964. The ship moored in front of the New Fresh Wharf carries an 'A' on its funnel, thus implying it was operated by the Aznar Line. The name of the ship is just visible by the bow, and is the *Monte Ulia*.

The building next to the warehouse is Billingsgate Fish Market. For many centuries this was one of the main wharves in London, for fishing vessels in particular, and it gradually became the main fish market. The current building was opened in 1877 and designed by Sir Horace Jones. The market was finally closed in 1982, when it moved to a site on the Isle of Dogs, but the original building remains.

Continuing along the waterfront is the Customs House. There have been several buildings on this site and the current one dates from the late 1820s. Part of it was destroyed by a bomb in the Second World War and rebuilt to its original design. The riverside façade is over 1,000ft long.

As in previous photographs of this period, the highest building on the skyline is the old PLA head office.

The changes in this section of the river façade are well shown in the lower right photograph opposite. New Fresh Wharf, which was a post-war building, has been demolished and replaced by a modern office block.

Above: 'Cranescape', New Fresh Wharf, 1964.

Right: Car park in front of Adelaide House, Tower Bridge and HMS *Belfast*, 1995.

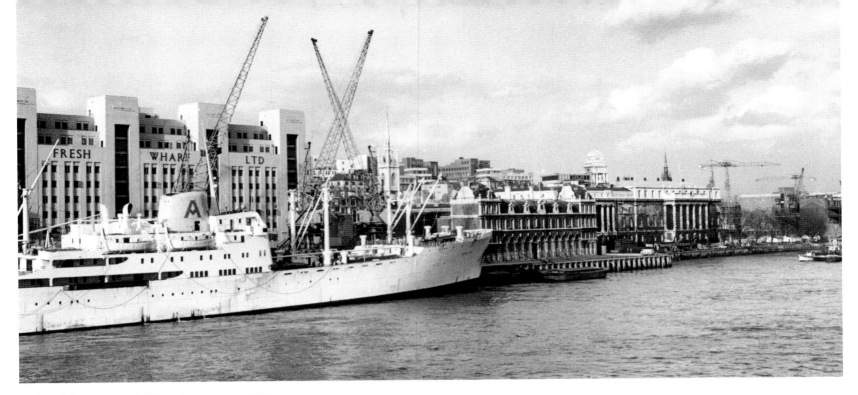

Below left: New Fresh Wharf and ship, 1959.

Below right: Adelaide House, the Monument, NatWest Tower, and the new office block that has replaced New Fresh Wharf, 1995. One building that has remained is the Monument. This was built to commemorate the Great Fire of London of 1666 and is sited at the place where the fire began. The Monument, designed by Sir Christopher Wren, is 202ft high, and is built of Portland stone. It is claimed to be the tallest isolated stone column in the world.

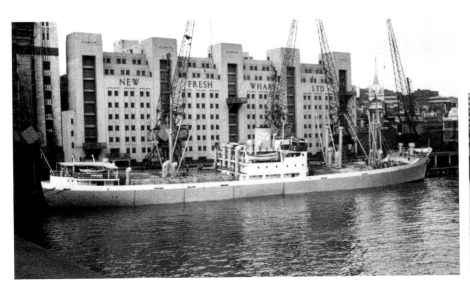

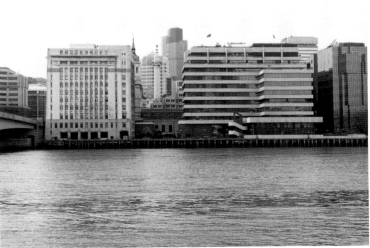

Tower Bridge photographed at dusk, 1964. A view from a bygone age taken from London Bridge showing Tower Bridge, cranes and warehouses in the pre-HMS *Belfast* days.

CHAPTER 3
LONDON BRIDGE TO SOUTHWARK BRIDGE

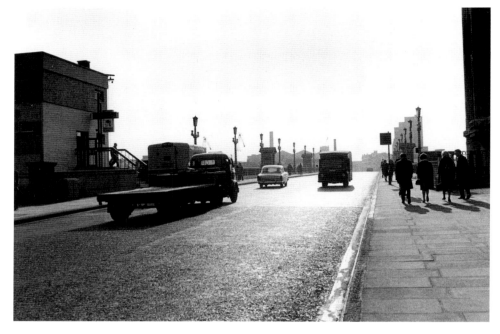

Previous page: Southwark Bridge and Bankside Power Station at dusk, 1964. This is a classic dusk view of the river as it used to be. The tall chimney with smoke pouring from it is the Bankside Power Station (now the Tate Modern), and in the distance the sun is setting behind the Shell building. To the right of the big chimney is the tall slim Oxo tower. To complete the scene a tug is pulling a barge down river.

Southwark Bridge is the third road-bridge covered in this photo essay, and the stretch of water between this bridge and London Bridge also includes Cannon Street railway bridge, which is shown in several photographs in this chapter. The first Southwark bridge was built in 1814-1819 by John Rennie, but was replaced in 1912-1921 by the current structure designed by Sir Ernest George (which is, of course, the one seen in this sequence of photographs).

Above left: Road across Southwark Bridge, 1964. Although taken on a workday, the road across the river is surprisingly quiet.

Left: Southwark Bridge and the *Financial Times* office, 1995. Although the viewpoint is somewhat different from the photograph above, a comparison immediately highlights the changes that have occurred on the southern side of the river over the intervening three decades.

Opposite top: St Paul's Cathedral framed between the towers of Cannon Street railway station, 1959. The station's twin stone towers were blackened by the soot from the smoke of the many thousands of steam trains that had entered the station from the time it was opened in 1866. The reason why these towers appear in so many photographs is that they were relatively high compared to their surroundings, being some 110 feet tall.

Bottom: The same view in 2002. Many changes are clearly shown in the comparison between these photographs. Perhaps the most striking are the new office blocks, including the offices between the twin towers and the fact that the towers have been cleaned.

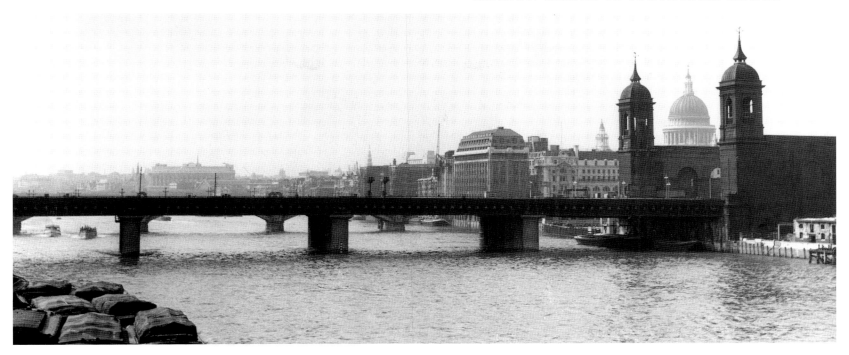

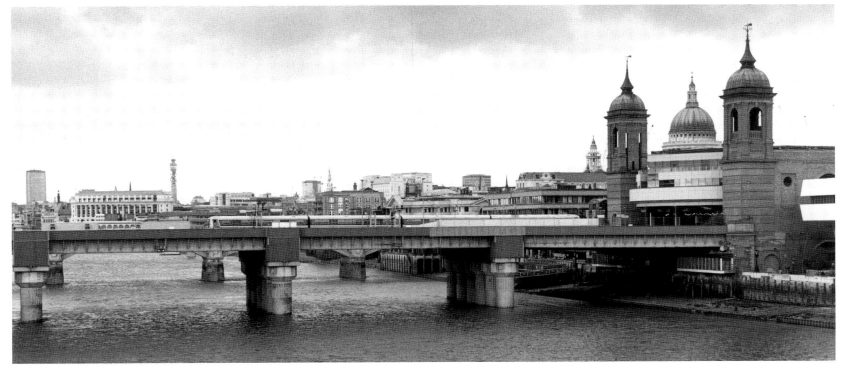

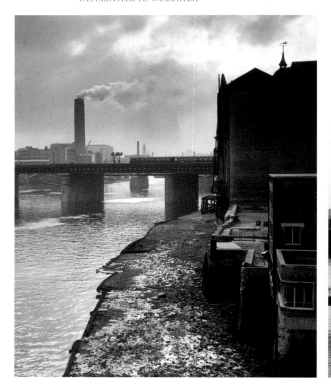

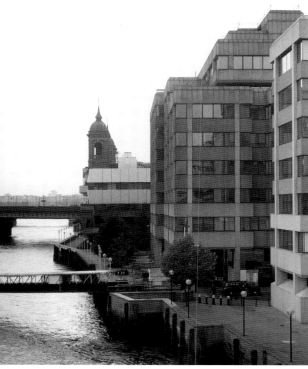

Far left: Bankside Power Station and Cannon Street railway bridge, from London Bridge in 1964. The Oxo Tower is visible in the distance. This scene was taken near low tide as so much mud is visible.

Left: Taken from virtually the same position in 1995. Nowadays, large new office blocks dominate the riverbank, and there is a walkway. The clean towers of Cannon Street station stand out clearly.

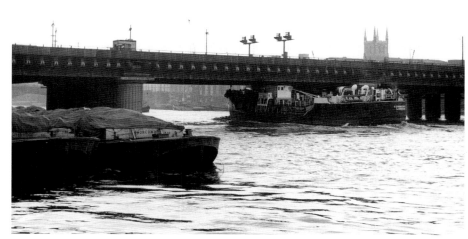

Cannon Street railway bridge and Southwark Cathedral, 1964. Note how the funnel of the barge passing under Cannon Street railway bridge has been lowered. This was a key feature in the construction of many of the craft to use the river and can be seen again in a tug later in this book. The only point to appear above the bridge is the tower of Southwark Cathedral.

The same view in 2002. The cathedral tower is no longer the highest point, but dwarfed by the high-rise buildings (flats and offices). The river vessel is a tourist boat, not a 'working' barge. An indicator of the importance of tourism is that this passenger vessel was operating in January!

Above right: Cannon Street railway station towers from Southwark Bridge, 1995.

Below: This photograph was taken from Southwark Bridge in 1964 and shows the northern shore towards Cannon Street railway station – the station appears as the dark mass at the back of this scene. There is a path in front of the building from which some subsequent photographs of Southwark Bridge were taken. On the first floor is a pub and people can be clearly seen inside sitting at tables and presumably eating as well as drinking. This scene was taken at a fairly low tide which means that the riverbank walls can be clearly seen. There is a footpath in front of the pub and the two photographs on page 42 were taken from this path.

The scene has now greatly changed, as is evident from the two views on the right. The main points have been made previously – new offices, the disappearance of old buildings and the clean tower of the railway station. However, there are two other developments which can be seen by looking at the top photograph. In 1964 there was an entrance to a small dock close to the railway station, but this has been completely closed and is nowadays part of the Thames footpath.

Below right: The same viewpoint in 1999. The other change is witness to a different use of the river, which is the importance of leisure. Here there is a banner advertising the Little Ship Club and to its left a flagpole and standard.

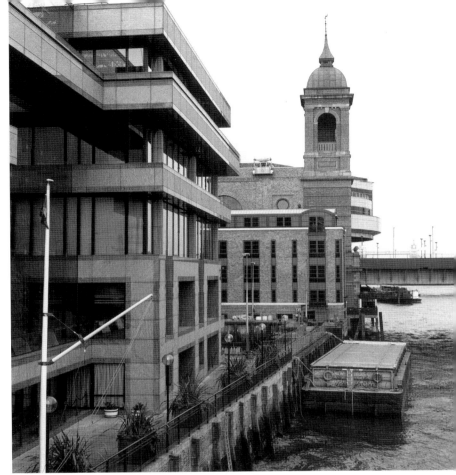

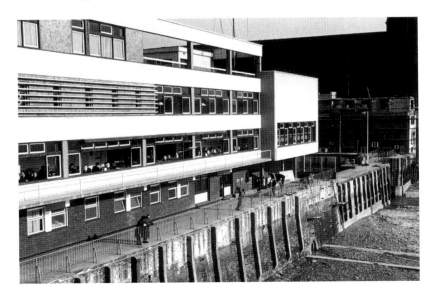

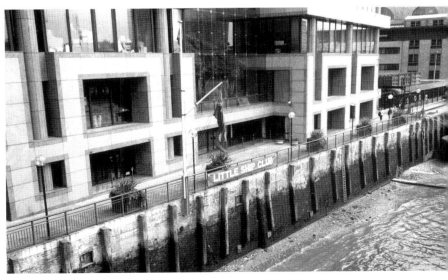

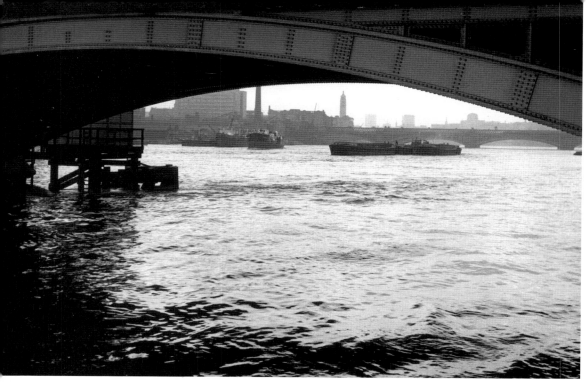

Opposite: View to Blackfriars Bridge from Southwark Bridge, 1964. In the foreground are some of the old Victorian warehouses and barges with men working on them. Beyond Blackfriars Bridge, going from left to right, are the Oxo Tower, the old Shell Mex building (rather faint in the haze), the start of Blackfriars station and behind that Unilever House.

The changes in this part of the river, particularly on the south bank, are quite different from those noted so far. In the stretch between Tower Bridge and Southwark Bridge the emphasis has been on the construction of office buildings in place of the old warehouses, but here the change is to tourism and learning. Thus while the old photographs still recall a working river, the current views are of the Tate Modern, the Globe Theatre, the Millennium footbridge; a new pub and, on the north bank, the City of London school now occupy space that was once warehouses.

Two photographs of Southwark Bridge, 1964. Blackfriars Bridge appears in both scenes as well as river craft and, in the top view, the Oxo Tower.

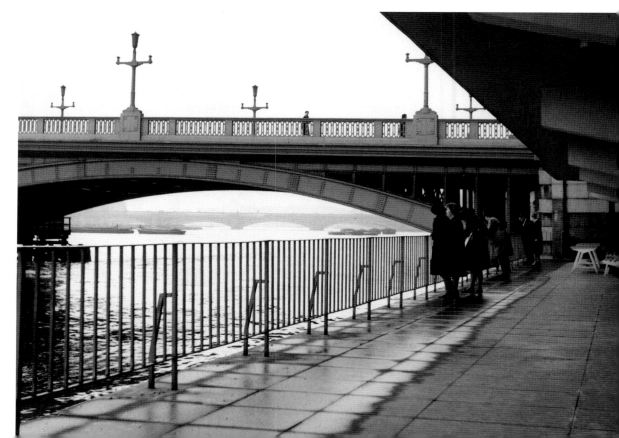

CHAPTER 4
SOUTHWARK BRIDGE TO BLACKFRIARS BRIDGE

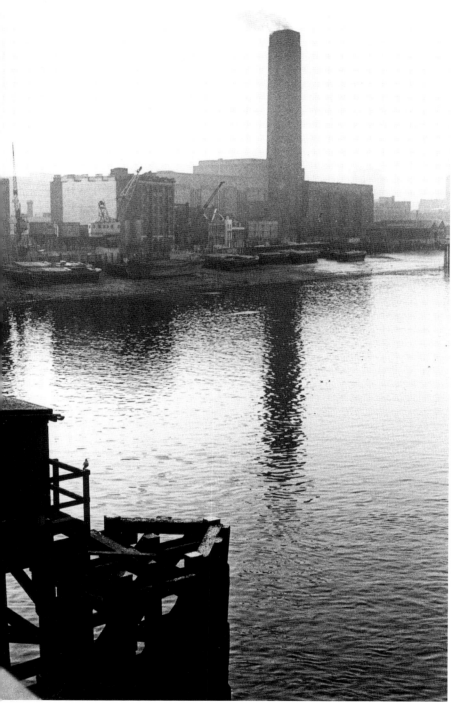

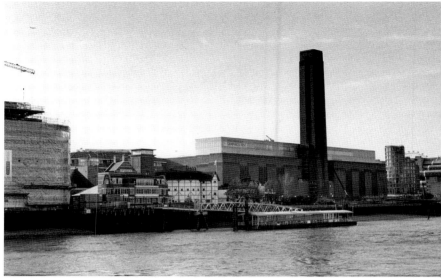

Left: Bankside Power Station in 1964, since when there have been major changes in the river frontage, as described below.

Above: Tate Modern Art Gallery and the Globe Theatre, 1999. This photograph was taken from precisely the same place as the one to the left, namely the northern end of Southwark Bridge. All the small buildings, cranes and jetties have disappeared and in their place are modern buildings, a new pier and the Globe Theatre.

Bankside Power Station was opened in 1963 having been designed in 1947 by Sir Giles Gilbert Scott. It has ceased operating as a power station and instead is the Tate Gallery of Modern Art. The gallery was opened in 2000 as part of the Millennium celebrations and has become very quickly one of the most popular attractions in London. It has some 100,000 square feet of available space for exhibits and has been given a glass roof to help illuminate the inside of the building.

The Globe Theatre is a reconstruction of the one in which Shakespeare had been a part owner and in which many of his plays had been performed. His theatre had been burnt down in 1613, and although rebuilt its successor was closed by the Puritans in 1642 and pulled down two years later. The driving force behind the current Globe was an American actor, Sam Wanamaker, and it has been built on a site about 200 yards from the Shakespearian Globe. Construction commenced in 1992 and the theatre opened in 1996. It is a theatre 'in the round', thatched, while the central area is not roofed but open to the skies.

Above: Also taken from Southwark Bridge, this photograph shows the north bank of the river and Blackfriars Bridge in 1964. Clearly seen in this photograph and several others during the 1950s and 1960s is 'river mud' but it is much less evident in the modern views.

Below: This photograph was taken in 1995 from almost precisely the same spot as the one on the left. The comparison between these two photographs emphasises once again the substantial changes that have taken place on the waterfront in this period. The old warehouses have been demolished and replaced by modern office blocks. The Portico building dominates this scene and reconstruction work on this site started in 1991 to plans/designs of the Whinney Mackay partnership. Architecture, and the look of new buildings, is very much a matter of personal taste and some may find this a magnificent structure to grace the riverside – others may think it is pretentious.

Blackfriars Bridge appears in both these views and the one shown in this set of photographs is the second constructed at this site. It was built in the 1860s to a design of five wrought-iron arches and was opened by Queen Victoria in 1869. It is the widest bridge in Central London. Unilever House is visible behind the bridge.

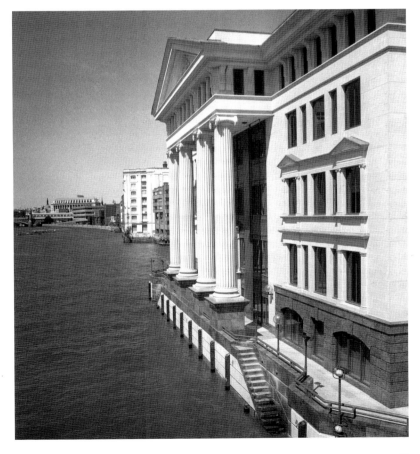

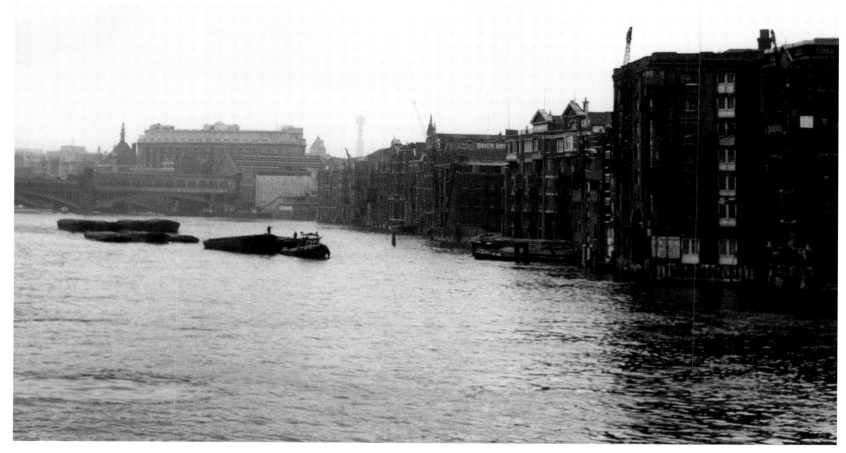

Barges and warehouses on the north bank photographed from Southwark Bridge in 1964. Also included in this view is part of Unilever House and Blackfriars Railway station while just visible on the horizon is the BT Tower.

The warehouses on the right date from the Victorian period, but this stretch of the river had for many centuries been part of London's docks. Within this row of buildings was a small inlet called Queenhithe, and there is a mention of a quay at Queenhithe before AD 900. It was thus a very ancient dock and by the time of the Middle Ages it was the busiest part of the then Port of London. However, its location is well up river and so as ships became larger its importance began to diminish. Nevertheless, even in the 1960s, as shown in this scene, the waterfront was still active.

While the photograph on the opposite page is from a different viewpoint it is comparable as it shows the same part of the river frontage. The old warehouses have disappeared and in their place are blocks of offices, apartments and the City of London school. The top left photograph on page 48 again covers the same river frontage but specifically shows Lord Foster's Millennium Footbridge. This was the first new bridge for many decades but was quickly closed due to its instability. It is now fully open.

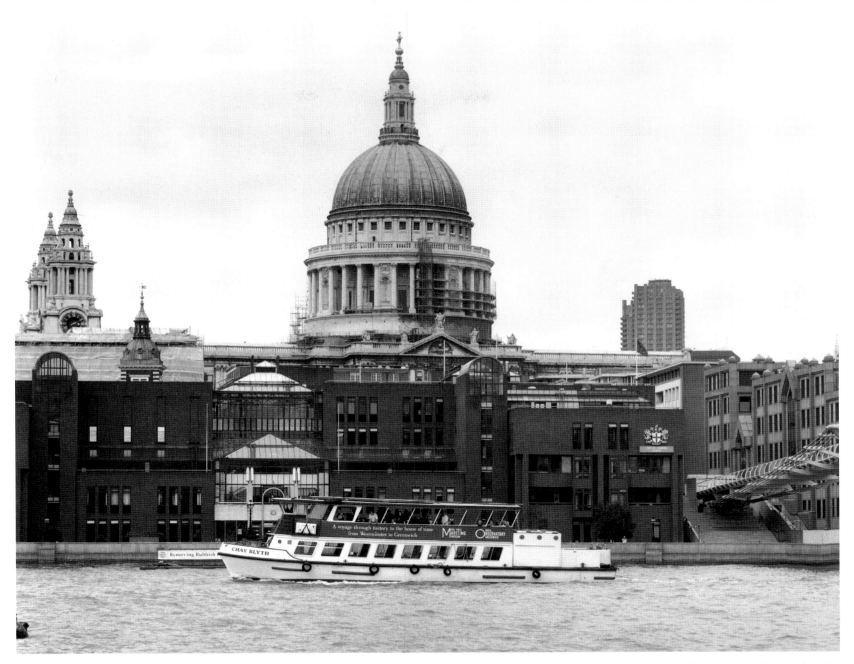

St Paul's Cathedral from Tate Modern, 2000. Wren's masterpiece is the dominating building on the skyline in many photographs in this book. It is the fourth such cathedral, and was built after the Great Fire of London in 1666 (work commenced in 1675 and completed in 1710).

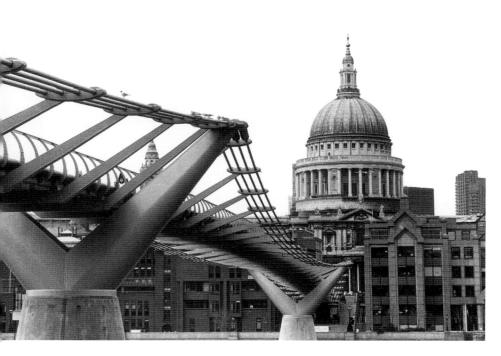

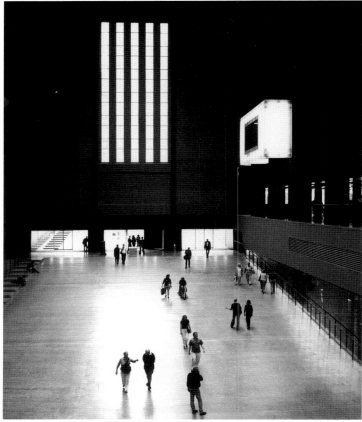

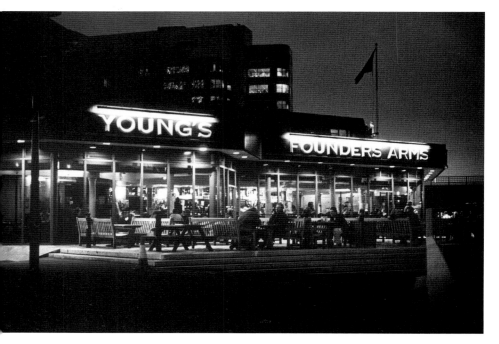

Above: This photograph, taken in 2000, shows the main hall inside the Tate Modern Gallery, which once housed the power station's turbine generators.

Above left: Millennium Footbridge and St Paul's Cathedral, 2001.

Left: The Founders Arms Pub, 2001. The photographs on this page reflect the changing nature of the waterfront, being involved with tourism and leisure. The Founders Arms is a relatively new building, and is owned by Young's Brewery which is only one of two companies still actively brewing beer in London (at Wandsworth) and still family controlled.

CHAPTER 5
WATERLOO BRIDGE

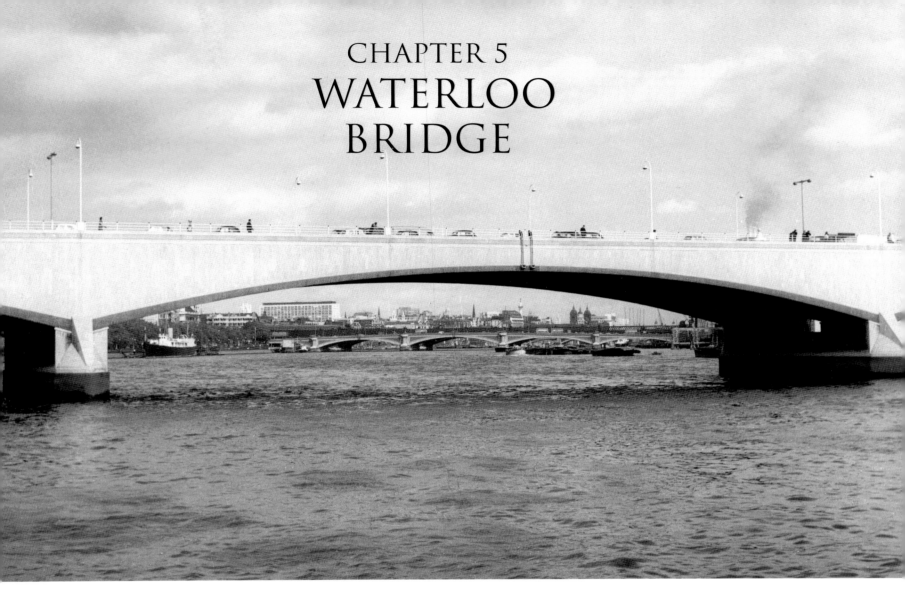

Waterloo Bridge and view down river, 1959. There is a skyline devoid of high-rise buildings, and instead the tallest structures are the Monument and the black towers of Cannon Street railway station. Blackfriars Bridge is also visible. The author tried to take a 'now' picture of this scene, but it was impossible due to the many jetties operated by river-boat companies. The changes in the skyline as seen from this part of the river will become evident during later photographs in this chapter.

The first bridge at this point in the river was by John Rennie, but the current structure is from a design by the architect Sir Giles

Gilbert Scott. It was built in the period 1937 to 1942; the 'clean' lines and modern design make this bridge very different from the other London road bridges included in this essay. It is one of the few buildings on, or across, the river photographed in the 1950s and 1960s that clearly had no Victorian antecedence.

This is the second reference to Scott's work, as he designed the Bankside Power Station, the main hall of which is shown opposite. He had a further influence on the river landscape as he was also the designer of Battersea Power station.

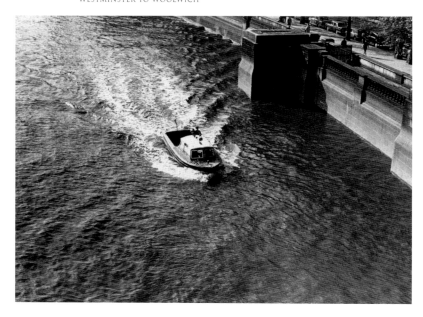

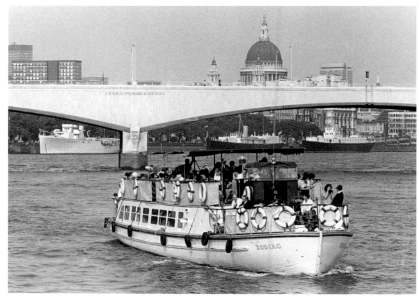

Above: Police launch and Victoria Embankment, 1961 – seen from Waterloo Bridge.

Above: St Paul's Cathedral dominates the skyline. The clean modern lines of Waterloo Bridge are behind the pleasure boat, which is full of people enjoying a sightseeing trip along the river in 1970.

Below: Waterloo Bridge, 1962. The trees border Victoria Embankment which passes under the bridge and the fine building behind and to the right is Somerset House (built in the 1780s). The barge moored in the centre of the river was owned by T. Woods (Launches) with a number BER 1064 marked beside the name.

Below: Waterloo Bridge at dusk, 2001. Behind the bridge are the Shell Mex building and the Savoy Hotel. While there has been little change in these buildings over the past few decades, this is not true of the vessels moored on the river. Instead of a barge are many sight-seeing boats and berthed beside the Victoria Embankment is a large ship that is used as a bar-restaurant.

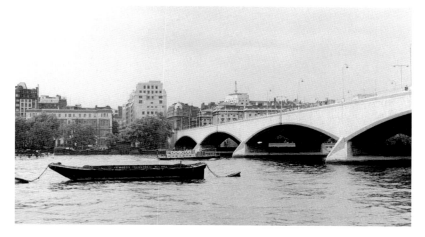

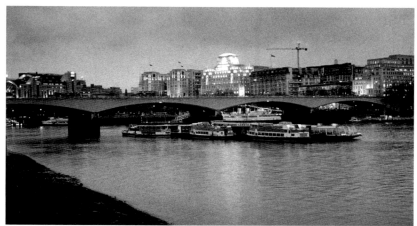

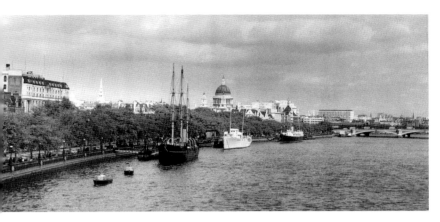

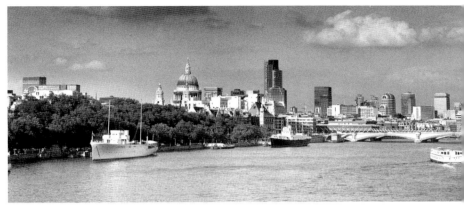

A view down river from Waterloo Bridge taken in 1959. This is another classic view of the Thames. St Paul's Cathedral again dominates the skyline, and to the right is Blackfriars Bridge. The three ships are, from left to right, RRS *Discovery*, HMS *President* (a First World War sloop) and HQS *Wellington* (the floating livery hall of the Honourable Company of Master Mariners) – all three being moored in a stretch known as the King's Reach which is opposite the Temple.

RRS *Discovery* was a ship used by Captain Robert Falcon Scott for a polar expedition in 1901. 'RRS' stands for Royal Research Ship and this vessel was specifically designed to withstand the stresses of working in the Antarctic waters and ice packs. It was commissioned by the Royal Geographical Society and was one of the last three-masted wooden vessels to be built in Britain. It was constructed in Dundee, mainly from oak and elm, and was launched in 1901. It was used in Scott's 1901 expedition and was caught in the ice packs for two years, before Scott returned in 1904. As evident from the picture opposite, the ship is no longer moored in the Thames but is now the centre of an exhibition at its place of construction – Dundee.

To the left of the two top pictures is a church spire that is sometimes described as a wedding cake. This is St Bride's Church, which appears on the horizon in several photographs in this essay. There have been religious buildings and churches on this site since Roman times, but the current church was designed by Sir Christopher Wren in 1671 after the previous one had been destroyed in the Great Fire of London. The spire was added in 1701-1703 and it became the tallest of Wren's steeples, currently standing at just under 230ft. Much of the church was destroyed in an air raid in 1940, and was subsequently rebuilt and rededicated in 1957. Being close to Fleet Street (which was once the hub of national newspapers) it is often called the 'printer's church'.

Above: The same viewpoint as the picture left but taken in 1995. In the intervening thirty-six years the *Discovery* has moved and St Paul's Cathedral is no longer the tallest building.

Below: This photograph continues the pan to the south side of Blackfriars Bridge, and shows that in 1995 the Oxo Tower was lower than many of the surrounding buildings. This is so different from the 1960s when the slim tower is visible in many of the photographs in the earlier chapters.

The Oxo company was well known as a producer of 'beef stock cubes' and other stocks for use by cooks and housewives in their own homes. There was an outdoor advertising ban in the 1930s and to overcome the ban the Oxo company built a tall tower on its own warehouse and had the letters 'OXO' embedded in the tower's brickwork. The warehouse has recently been renovated with boutiques, artists shops and restaurants, while on the top floor there is now a Michelin-starred restaurant.

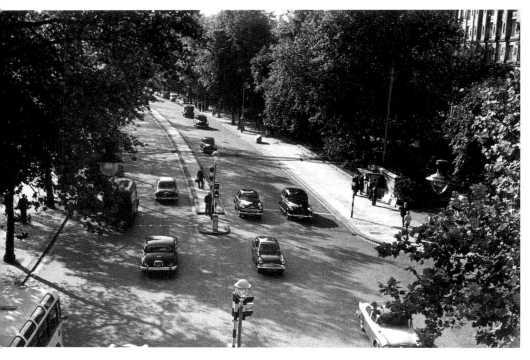

Victoria Embankment, 1961. Alongside the river on its northern bank is the Victoria Embankment, which runs from Blackfriars Bridge to Westminster Bridge. Waterloo Bridge crosses the Embankment and so it is possible to look down onto the road. In this photograph the camera was pointed towards Westminster.

The designer of the Victoria Embankment was Sir Joseph Bazalgette, and it was constructed in 1864-1870, with a wall that was 20ft above the then high water mark. In recent times, at high tides, the river is only a few feet below the top of the retaining wall; hence the Thames Barrier (see later). While the design of the road has changed little in the intervening years, the level of traffic has increased considerably as this is now one of the main through routes across London.

The three photographs on this page highlight many of the changes that have occurred over the intervening four decades. There are no yellow lines on the road, no parking meters, the roads are virtually deserted, as are the pavements, and car designs have moved on. One intriguing detail from the view left is the small newspaper kiosk on the side of the pavement.

Below: Victoria Embankment, 1962. Note the complete lack of any parking controls, such as meters or yellow lines on the road surface. The parked car is a Ford Anglia.

Below: Victoria Embankment looking towards the City including RRS *Discovery*, 1962.

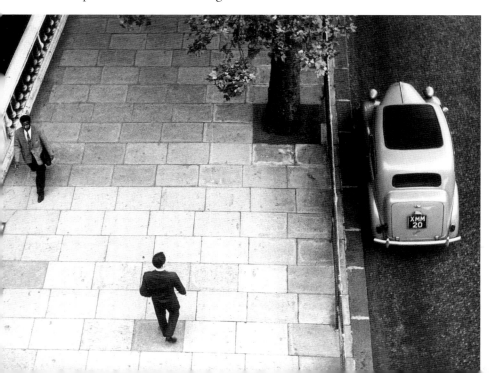

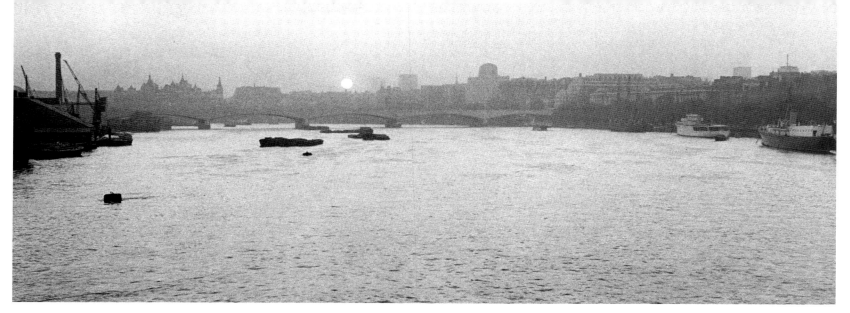

Waterloo Bridge at dusk, seen from Blackfriars Bridge, 1962.

St Paul's Cathedral, Blackfriars Bridge, NatWest Tower and other City tower blocks seen at dusk, 2001. Even with the changes over the past decades, the river still has a wonderful 'mood' at dusk.

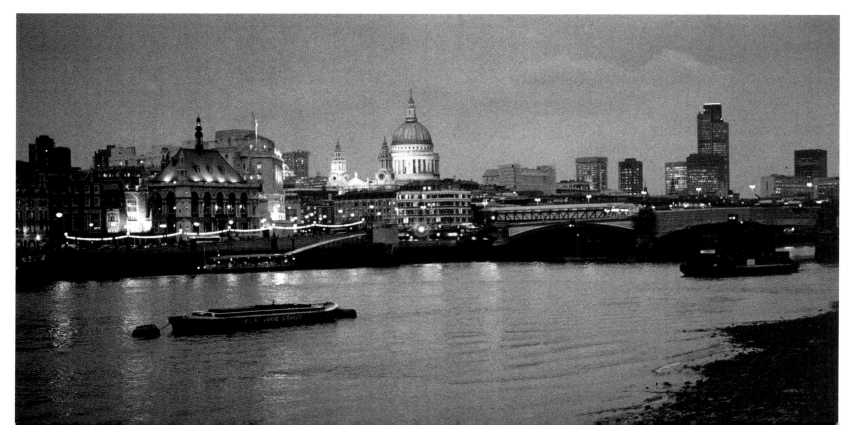

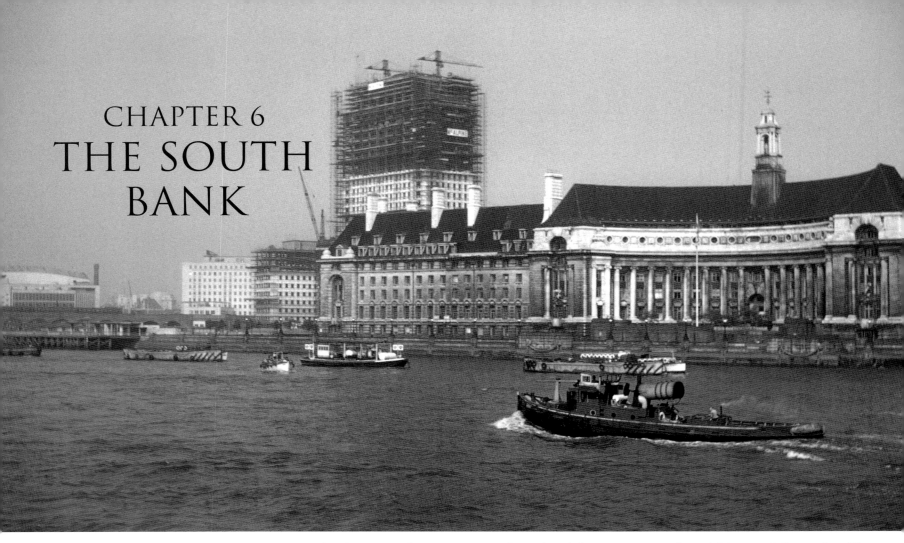

CHAPTER 6
THE SOUTH BANK

Up to now the title of each chapter has been related to a specific bridge or a stretch of water between two bridges, but this one is different. It refers back to the 1951 Festival of Britain and while there were events throughout the country, without doubt the 'Festival's centrepiece' (to use the words of the official programme) was the South Bank Exhibition. The area occupied by the Exhibition site had been marshy land and only developed after the First World War. This redevelopment comprised three major projects – improvements to Waterloo railway station, a new Waterloo Bridge and the construction of the LCC County Hall (as it was then called) – creating a triangle into which the South Bank Exhibition was slotted. The opening ceremony was attended by King George VI at St Paul's Cathedral on 3 May 1951, and the

South Bank Exhibition was open from 4 May to 30 September. The Dome of Discovery and the Skylon were two notable attractions, but the one building to remain is the Royal Festival Hall. This photograph, taken in 1959 or 1960, shows from left to the right the Royal Festival Hall, the Shell Building under construction and County Hall. In front of the Royal Festival Hall is a viaduct supported by brick arches which carries the railway into Charing Cross station – this is called Hungerford Bridge.

This view captures a river scene that no longer exists. There have been many changes over the past four decades but attention should be drawn to the tug. Not only are they rarely, if ever, seen on the river nowadays, but its funnel has been turned down so that it can go safely under the bridges.

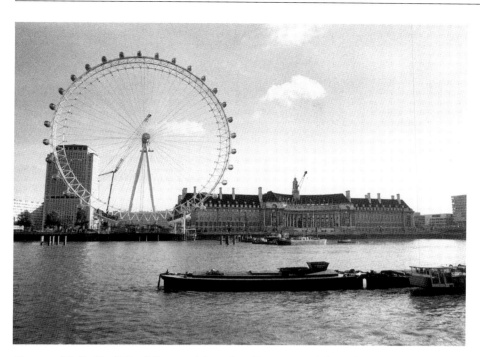

County Hall, Shell Building and London Eye, 1999. This photograph and those on the next page were all taken from the Victoria Embankment, and cover more or less the same stretch of riverside over some four decades.

Above: River frontage, 1958.

The earliest photograph, taken in 1958, shows the river frontage between the Royal Festival Hall on the left and County Hall on the right. The huge gap between these two buildings was the site of the South Bank Exhibition. This gap came to be filled by the Shell Building and other offices. There are several photographs of the Shell Building in this chapter and the one overleaf shows it under construction. It was completed by 1963 and was one of the first tall office blocks to be built in London, with a height of 350ft.

The predominant feature in the 1999 view is the large Ferris Wheel, called the London Eye and operated by British Airways. It has undoubtedly been one of the great successes of the Millennium celebrations and presumably its location in the centre of London has been a key reason for this as well as catching the public's imagination. The wheel is much higher than the Shell Building and, at 450 feet tall, it was the third highest structure in London when it was opened. Each revolution takes thirty minutes and each cabin holds twenty-five passengers.

Below: Shell Building, 1963.

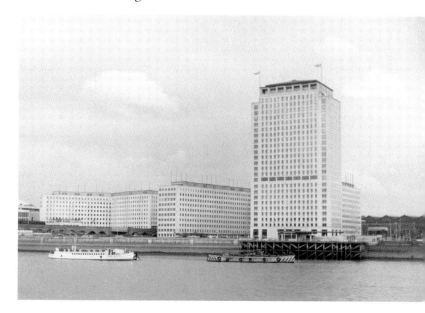

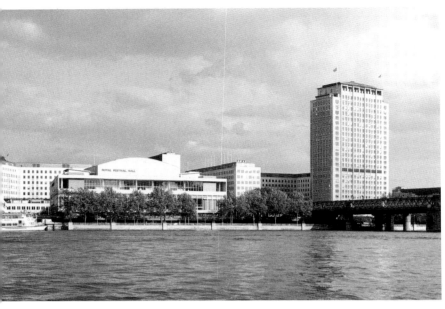

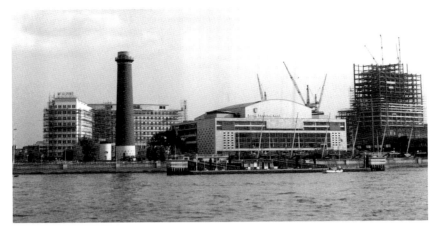

Above: Shot Tower, Royal Festival Hall and Shell Building under construction, 1959.

The Shot Tower, 120ft tall, had been a London landmark since its construction in 1826. Its purpose was the production of shot from lead. The molten metal was dropped from a melting chamber at the top of the tower and it formed perfect small spheres as it cooled in its fall down the tower. During the Festival of Britain it was converted into a lighthouse that flashed from sunset until the Exhibition closing time. The Shot Tower was demolished to provide room for the new buildings when the South Bank Arts Centre was extended in the early 1960s.

The Royal Festival Hall is the only permanent building remaining from the South Bank Exhibition. It was opened on 4 May 1951 with a series of inaugural concerts. The concert hall was built to seat an audience of 3,300 people, house an orchestra of over 100 players and accommodate a choir of some 250 singers. One of the aims of the planners was that the Hall could claim to be a work of art itself; the architects were Robert Matthew and Dr J.L. Martin and the chief engineer was Joseph Rawlinson.

Above: The Royal Festival Hall and the Shell Building photographed in 1999. The Shot Tower has long been demolished and trees give a 'softer' feel to an area where concrete walls predominate.

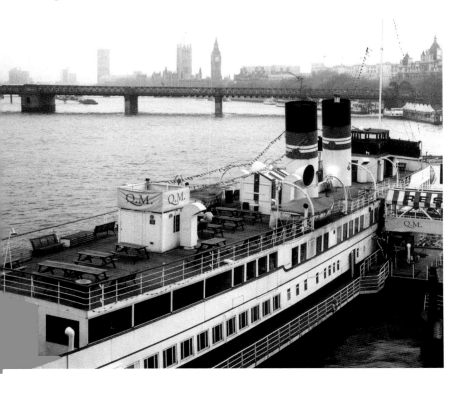

Left: This ship, *Queen Mary II*, is one of many vessels (photographed in 1995) now moored beside the Victoria Embankment that are used as restaurants and pubs. This is a major development since the 1960s that recognises the growth in tourism and changing UK lifestyles. It can happen because of an easing in the UK's licensing laws and a more relaxed attitude by the licensing magistrates.

Behind the ship is Hungerford railway bridge, which appears at the side of the photograph above left. It was completed in 1864 to a design by Sir John Hawkshaw and as well as taking trains into Charing Cross station it also incorporates a footbridge.

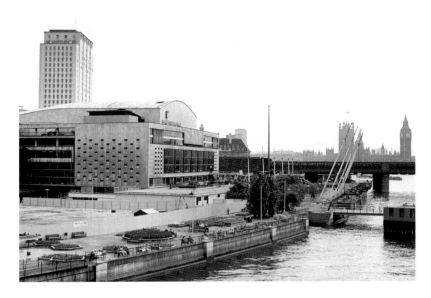

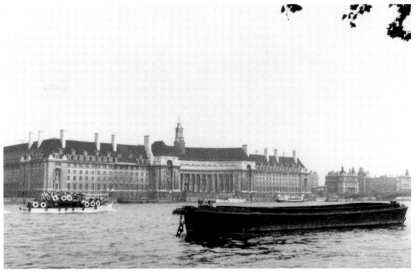

Above: Royal Festival Hall seen from Waterloo Bridge, 1962. The Shot Tower has now been demolished and the large area of open land would be used for the development of the South Bank Arts Centre. The dark bridge is Hungerford railway bridge and then in the distance is the outline of some of the buildings of the Houses of Parliament.

Above: County Hall, pre-1963. A straightforward view of County Hall, with a barge – once a common sight on the river. In the distance is Westminster Bridge and then beyond that is St Thomas's Hospital pre-redevelopment.

County Hall was the administrative headquarters of the London County Council (LCC), and it continued to fulfil that role when the LCC became the GLC (Greater London Council). County Hall was opened in 1922 by King George V, although the riverside frontage (featured prominently in many of these photographs) was not finished until 1933. The architect was Ralph Knott. The building fell into disuse after the abolition of the GLC, and after several different suggestions, it has finally become a hotel complex operated by Whitbread – one part under its prestigious international brand of Marriott Hotels, while the other part is a Travel Inn.

There are many changes since this photograph was taken and they can be summed up in one word – tourism. Where once the path in front of County Hall was quiet, it is nowadays full of tourists. In addition to the hotels, there is a MacDonalds, an art gallery, an aquarium and on the far left of the building is the ticket office for the London Eye. Tourists are everywhere, with all kinds of related activity such as hot dog stands, stalls selling film, postcards, pictures and so on.

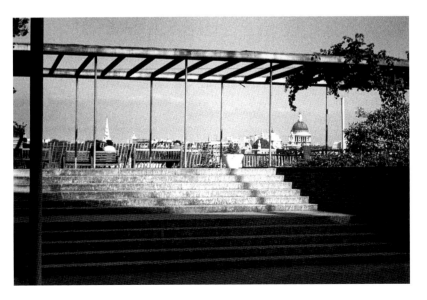

Left: St Paul's Cathedral from in front of the Royal Festival Hall, 1961. This wooden 'arbour' was a temporary structure and has since disappeared. As well as St Paul's, the spire of St Bride's church can also be seen.

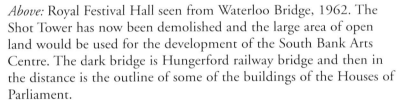

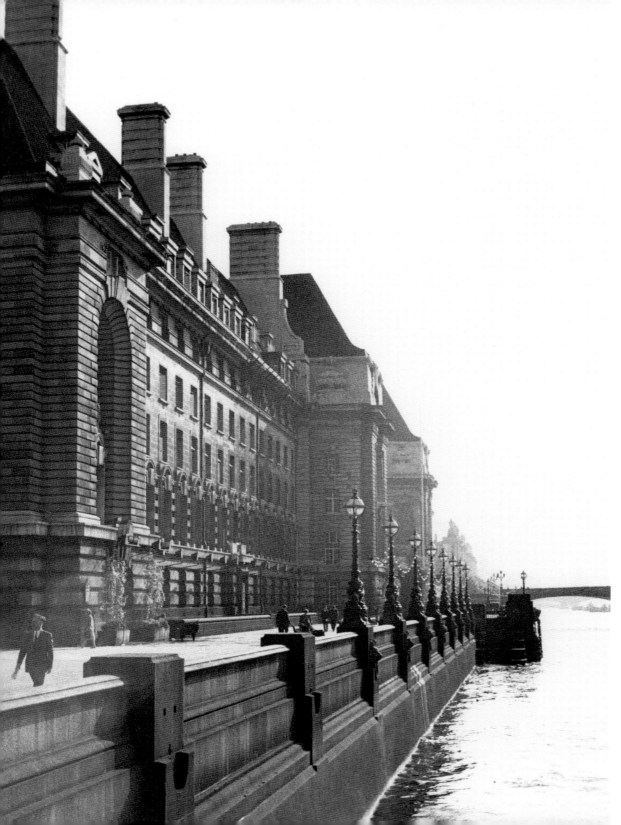

This is a view of the front of County Hall, showing the fine riverside lights, taken in 1961. There are a few pedestrians walking along the path in front of the buildings and as will be obvious from the comments on the previous page, the quiet calm evident in this photograph has long since disappeared.

Opposite page: Palace of Westminster and Westminster Bridge, 1962. This view was taken from the path in front of County Hall shown in the photograph on this page.

The first Westminster Bridge was opened in 1750, and at that time it was the only such crossing between London Bridge and Putney. However, it was replaced by the current structure in 1854-1862, with Sir Charles Barry acting as an architectural consultant. As can be seen there are several double-decker buses on the bridge.

The river links the financial centre (see the first chapters) with the political centre which is at Westminster. The Palace of Westminster is often referred to as the Houses of Parliament, containing as it does the House of Commons and the House of Lords. There has been a building on this site for several centuries, but following the fire of 1834 there was a need for a complete re-build. The current building was designed by Sir Charles Barry and Augustus Pugin in a style that has come to be known as Victorian Gothic.

In the background the top of Westminster Abbey can be seen appearing above the Palace of Westminster, close to St Stephen's Tower (more popularly known as 'Big Ben').

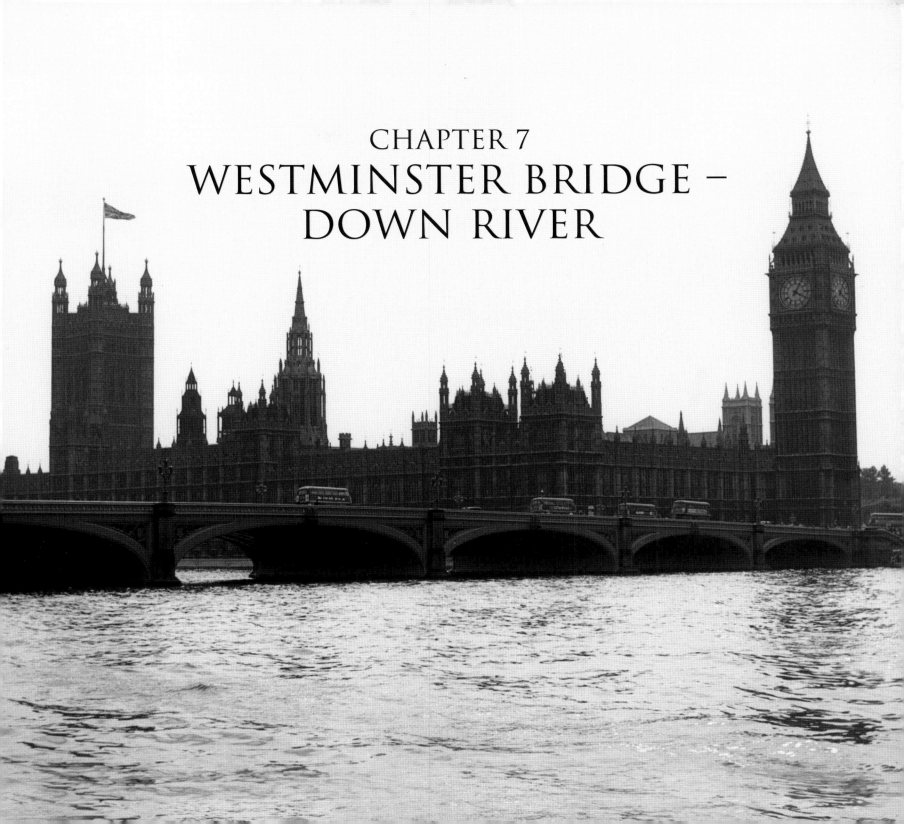

CHAPTER 7
WESTMINSTER BRIDGE – DOWN RIVER

Victoria Embankment and Westminster from in front of County Hall, 1961. Going from left to right are St Stephen's Tower and the twin towers of Westminster Abbey. The next building is on the corner of the Victoria Embankment and Bridge Street and has recently been demolished and in its place is Portcullis House (see opposite) and finally come the two blocks that comprise New Scotland Yard.

Westminster Abbey is more clearly visible in the photograph opposite. There was a great church on this site by the time of Edward the Confessor (1042-1066) and William the Conqueror was crowned here on Christmas Day in 1066. The Abbey was then substantially rebuilt by Henry III in the middle of the thirteenth century. However, its towers were added much later, in 1745, having been designed by Sir Nicholas Hawksmoor. Westminster Abbey is one of the great churches of England and pre-eminent in many state occasions such as the coronations of monarchs.

Scotland Yard was the headquarters (HQ) of the London Metropolitan Police and was designed by Sir Norman Shaw. It became operative in 1890, but the HQ moved to new premises in 1967. Some of the external surfaces were made from granite quarried by prisoners from Dartmoor prison, which seems pretty ironic.

The small boat in the middle of the river is acting as a petrol station and has long since disappeared.

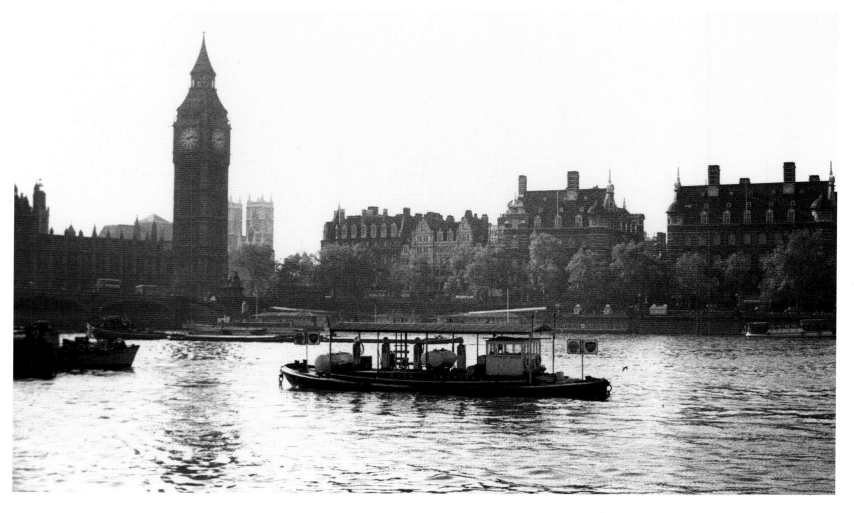

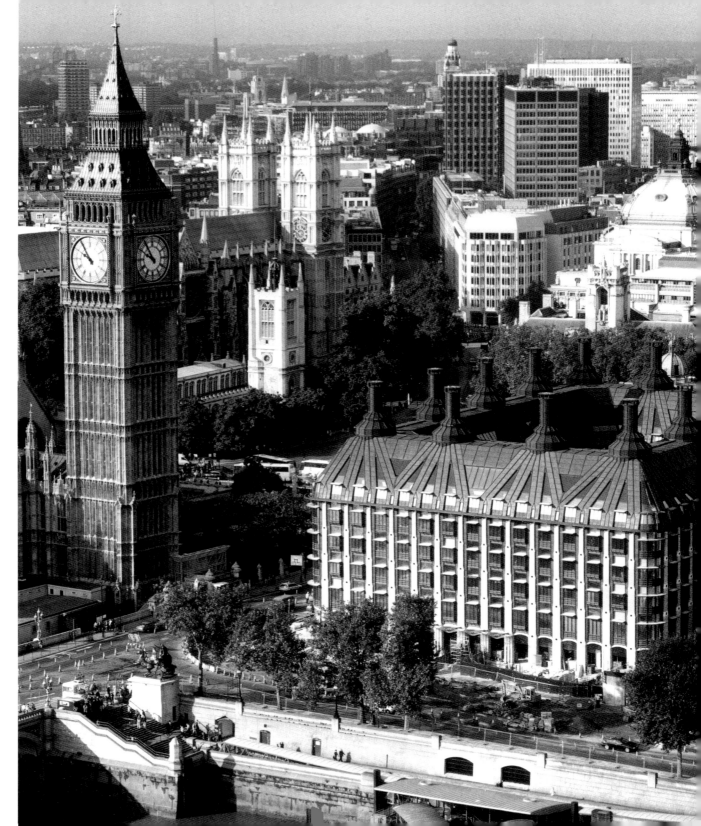

Westminster, from the London Eye, 2000. Going from left to right, this view shows St Stephen's Tower, the two tall towers of Westminster Abbey, then lower down the white tower of St Margaret's Church, and at top centre, peeping above the tower blocks of Victoria Street, is Westminster Cathedral. The new building on the right, facing onto the river, is Portcullis House.

Portcullis House was opened in 2000 at a cost of £231m and is designed for use as offices for Members of Parliament. The costs of this building have created some concern: for instance £150,000 was spent on providing twelve fig trees for the atrium.

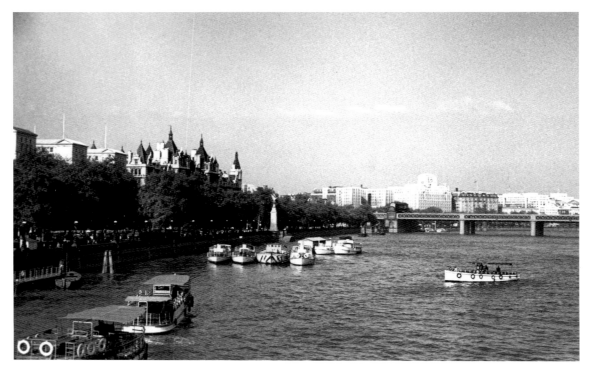

This is the first photograph of a panorama from Westminster Bridge, taken in 1961 and 1962, which stretches over the next two double page spreads. This shows the northern end of Hungerford bridge and beyond that the white building is Shell-Mex House.

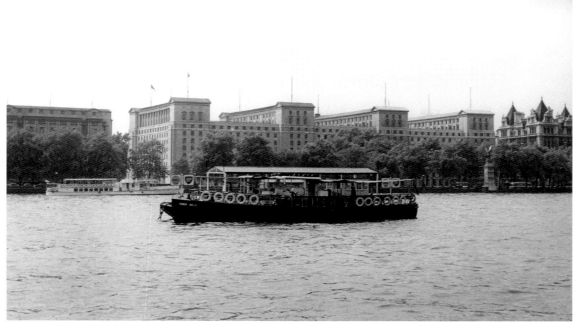

Ministry of Defence, 1962. Although now used by the Ministry of Defence the author thinks that at the time these photographs were taken it was known as the Air Ministry but has found no confirmation of this. This building was completed in 1957 and was designed by Vincent Harris and is seen here with a 1960s tourist riverboat.

This 1962 photograph continues the panorama from Westminster Bridge and encompasses the central portion of Hungerford Bridge from Shell-Mex House on the left to the Royal Festival Hall and County Hall on the right. The arches of the overhead railway line are clearly visible in front of the Royal Festival Hall.

The next double-page spread shows four photographs of the same part of the South Bank taken over a period of four decades, which are the final views of the panorama. As these photographs were taken from almost precisely the same position on the bridge many changes can be discerned:

By 1962 the Shot Tower has been demolished and the Shell Building completed.

By 1995 trees have almost totally hidden the Royal Festival Hall (RFH). There are many new office blocks and high-rise buildings, which means that the view to the City to the right of the RFH is now totally obscured.

By 2000 the London Eye has appeared and a new pier has been built in front of County Hall. This ferris wheel now towers above the Shell Building and, as noted earlier, it was the fourth highest structure in London when newly constructed. Its presence has indeed changed the entire riverfront and has led to a tremendous increase in tourism in this area.

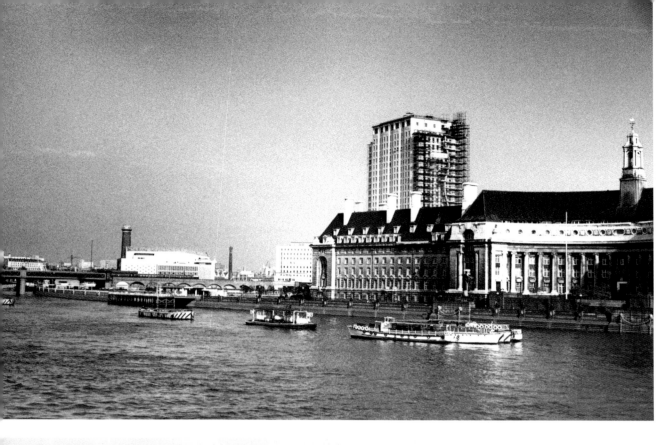

View from Westminster Bridge in 1961. The Shot Tower is still standing and the Shell Building is uncompleted.

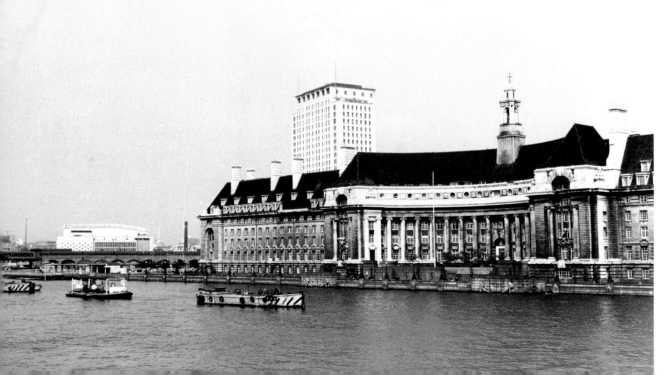

The same view in 1962.

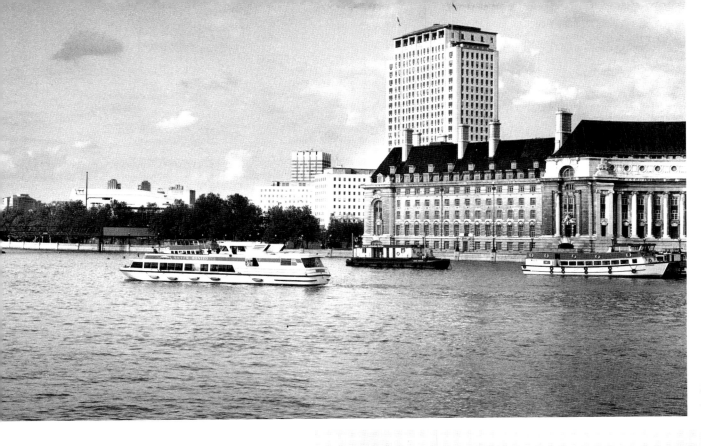

1995 and trees soften the concrete areas in front of the Royal Festival Hall.

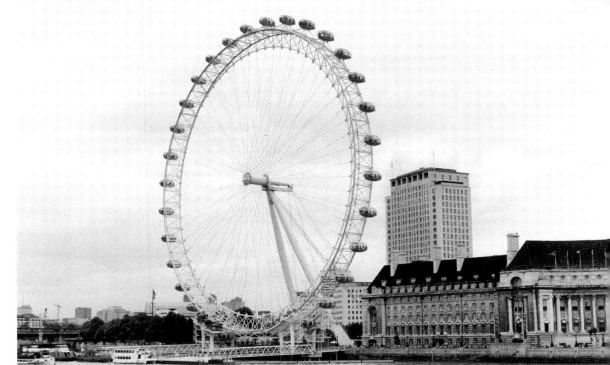

2000, by now the London Eye has been added to the riverside landscape.

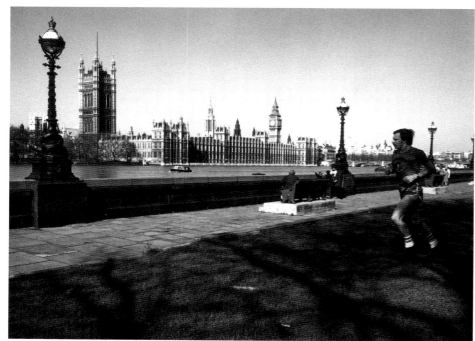

Above The Palace of Westminster seen in 1982 from the gardens that border the river between Westminster and Lambeth Bridges. To the left is Victoria Tower while 'Big Ben' is on the right. More accurately, the name of 'Big Ben' is applied to the Great Bell of Westminster, which is housed in St Stephen's Tower. In the foreground is a jogger, something that was unknown at the time when the earlier photographs were taken in the mid-1950s and 1960s.

Right: People queuing to see Sir Winston Churchill lying in state at Westminster, 1965. The link with an essay on the river is that Sir Winston Churchill, as the President of the Board of Trade, had been the Minister responsible for introducing the legislation that created the Port of London Authority in 1908.

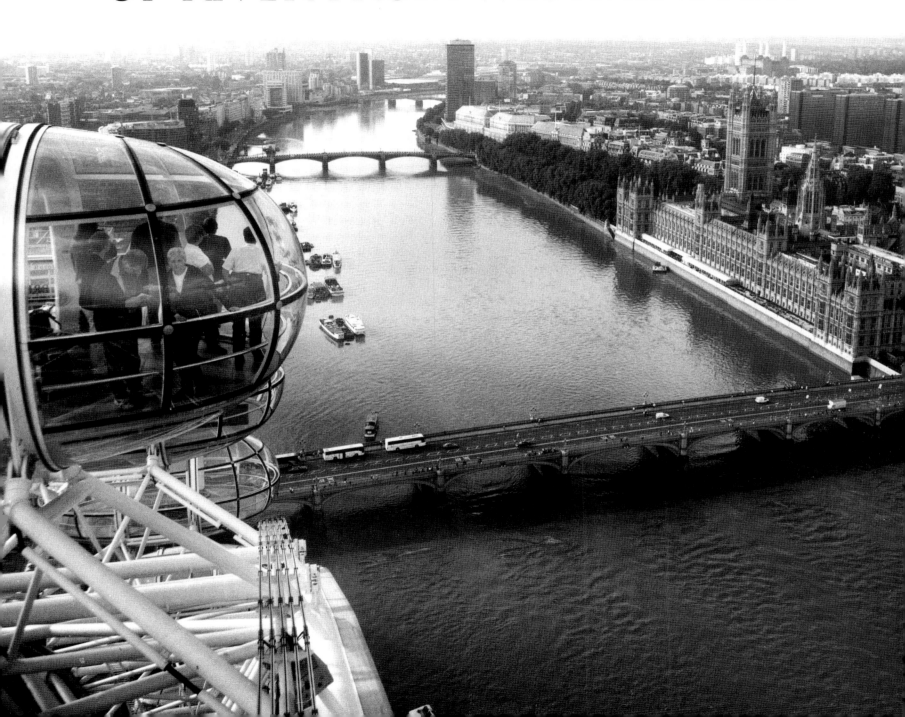

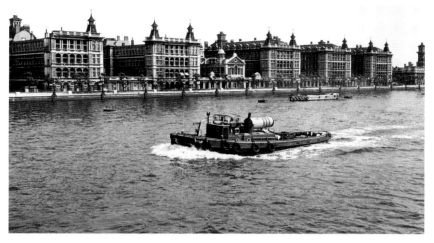

Previous page: Westminster Bridge and the view up river taken from the London Eye in 2000. Looking beyond Westminster Bridge is the Palace of Westminster and then there is a green open space with trees known as Victoria Tower gardens. The next bridge is Lambeth Bridge and beyond that, on the bend of the river, is Vauxhall Bridge. Just visible beyond the trees, on the right or north bank, is a white building – an office block – and then farther on is Millbank Tower.

Above Westminster Bridge the river always seemed less busy. From Tower Bridge to beyond Southwark Bridge the river was full of ships at dockside and barges on the river, and there was tourist activity from the piers at Tower Bridge, Charing Cross and Westminster but beyond Westminster the scene changed. Even today the river beyond Westminster Bridge is much quieter as the tourist activity mainly ceases at the Houses of Parliament and the London Eye.

The cabin on the left is part of the London Eye, the ferris wheel seen in previous photographs.

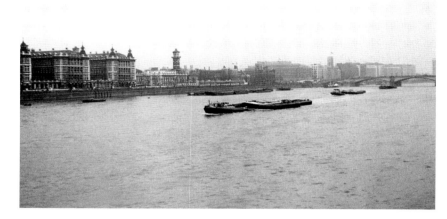

Top: St Thomas' Hospital, with tug, 1962. St Thomas's hospital was originally in Southwark and transferred to the present site in 1871, when this building was opened. The original buildings are seen in this photograph; most remain although there are new wings, mainly beside Westminster Bridge road.

As noted earlier, at one time tugs were a very common feature of activity on the river, but rarely seen nowadays. A feature noted with other vessels is that the funnel has been lowered so that the vessel can pass under the bridges.

The other two photographs on this page continue the panorama. In the middle print, between the hospital and Lambeth Bridge is Lambeth Palace, which is the official residence of the Archbishop of Canterbury. There has been a palace on this site since the twelfth century, but the building was extensively altered in the 1830s in the then popular 'Gothic style'.

There is some river activity in the lower photograph, which completes the panorama by showing the whole of Lambeth Bridge with parts of the Millbank Tower and Palace of Westminster on the right.

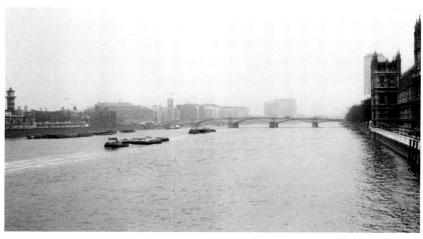

Middle: Albert Embankment from St Thomas's Hospital to Lambeth Bridge, 1965.

Bottom: Lambeth Bridge and barges, 1965.

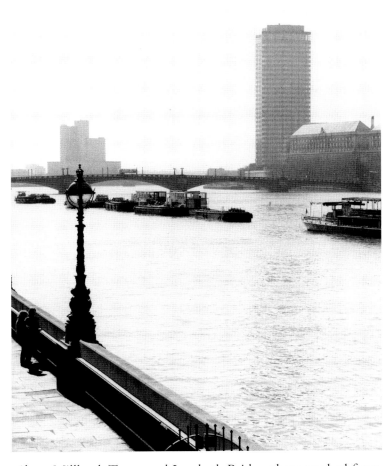

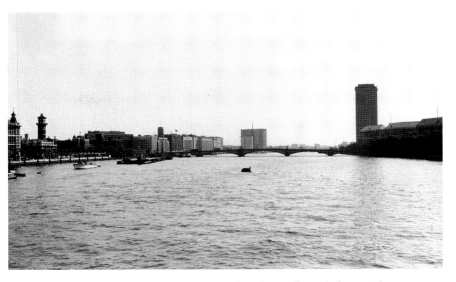

Above: This view from Westminster Bridge shows from left to right: St Thomas's Hospital, Lambeth Palace, Lambeth Bridge, the tall structure of Millbank Tower and then on the right-hand edge is a very distinctive office block. This photograph was taken in 1962, the year after Millbank Tower became the highest building in London. A comparison with the photograph on the left shows that Market Towers was yet to be built.

Above: Millbank Tower and Lambeth Bridge photographed from the Albert Embankment in 1982. The Lambeth Bridge seen in this set of photographs was built in 1929-1932, and is the second such crossing, the first one having been completed in 1862. Beyond the bridge is a group of tall buildings, which are Market Towers. The tall building on the right is the Millbank Tower, which at its topping out in 1961 superseded St Paul's Cathedral as London's tallest building at 387ft high.

Right: Millbank Tower, the trees of Victoria Tower gardens and finally a part of Victoria Tower itself. Although this photograph was taken in 2000, it is one of the very few views in this essay which could have been taken at any time over the past four decades.

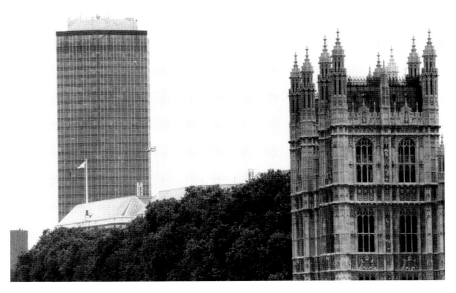

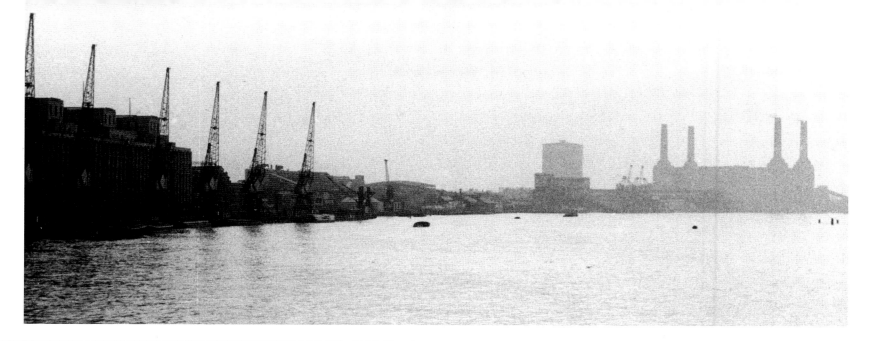

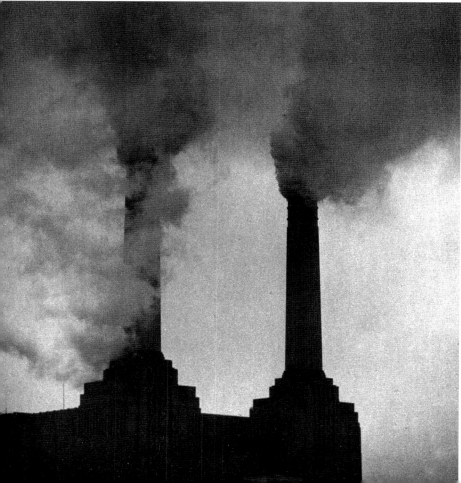

Most of this book has been about two specific changes in the river – the decline of the docks and the growth of tourism. However, this double-page spread is concerned with another major change that has occurred over the past four decades, and this is the decline of other economic activity on the banks of the river. In this case the emphasis is on production of electric power and as well as the two power stations featured here, many references to Bankside have been made in earlier chapters.

Above: Battersea Power Station 1959. The power station started operation in 1933 and ceased producing electricity in 1983. For many years it has been a shell, although at one time it was hyped as a site for a theme park. It was designed (like Bankside) by Sir Giles Gilbert Scott and was known colloquially as the 'Cathedral of Power'.

Left: Smoke pouring from the chimneys of Battersea Power Station in 1974.

Opposite: A view of Lots Road Power Station taken near to sunset in December 1984. This was possibly the most important of the power stations supplying the needs of London's Underground railway system. It was constructed in 1902 to 1905 at Chelsea Reach and it has recently ceased operation. Thereafter, the building would be transformed and the current plans are to turn it into an upmarket area of flats, shops and restaurants.

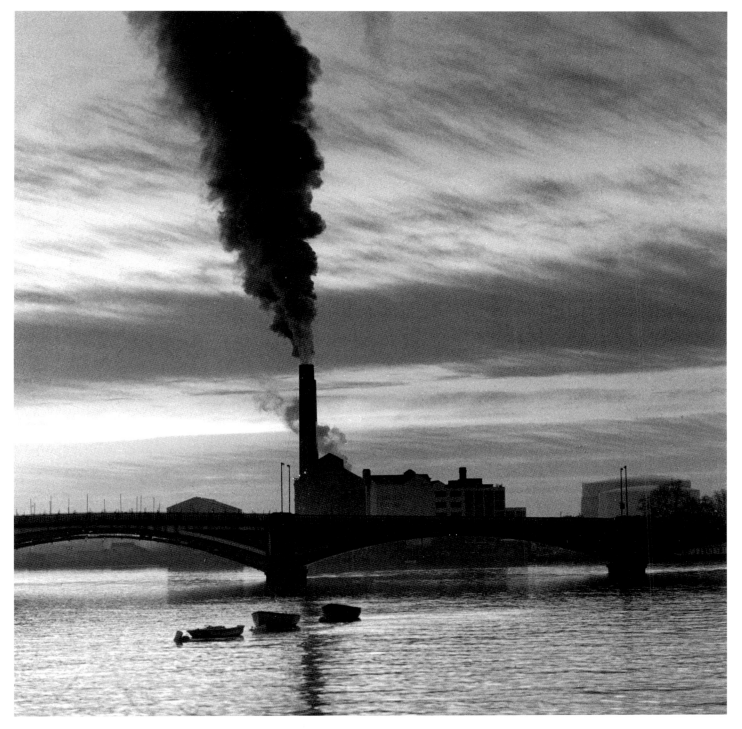

DOCKLANDS

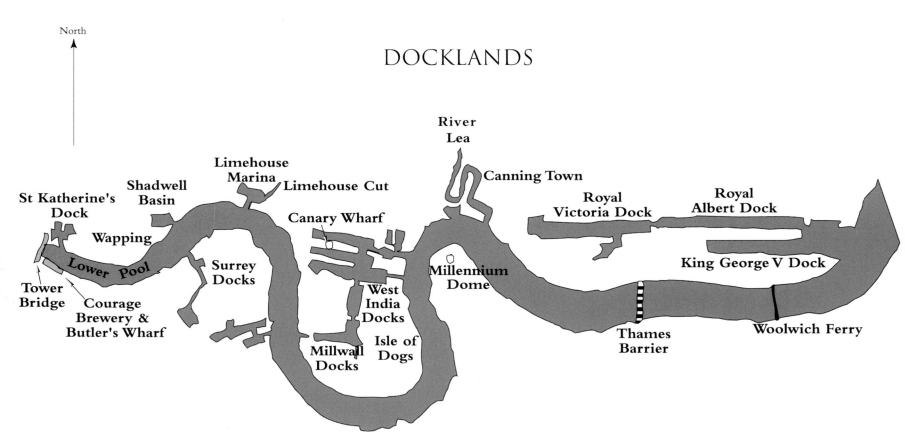

In this book the description 'Docklands' is used in its generally accepted sense to cover the stretch of the river between Tower Bridge to the entrance to the Royal Docks, a distance of some ten miles. This part of the river also covered the Lower Pool of London that stretched from Tower Bridge to approximately the entrance of what is now the Limehouse Marina. A brief chronology of when these docks were opened and closed is given in a table in the introduction.

One of the big changes that has occurred over the past four decades has been the decline of traditional dock activities in this area and the construction of modern upmarket apartments and of a major financial and commercial centre on the Canary Wharf complex. These developments will become evident in the photographs in the subsequent chapters.

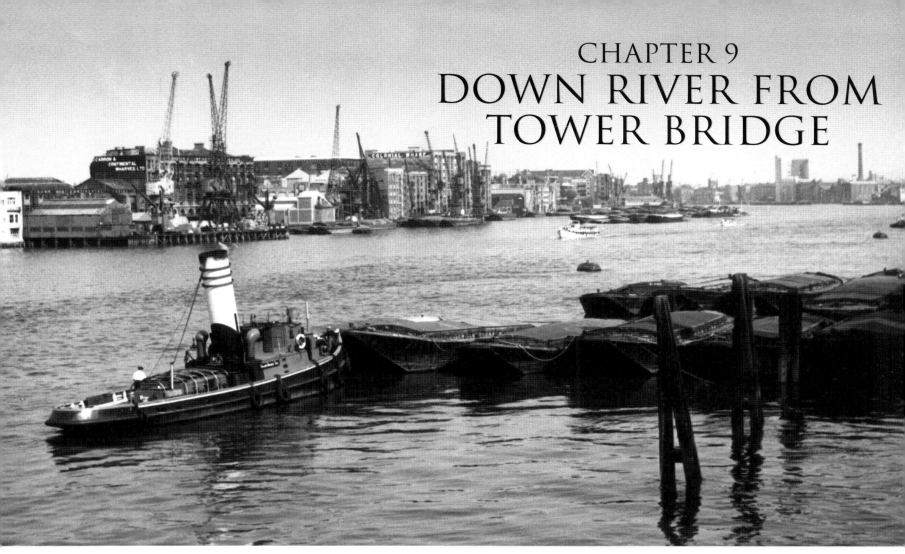

This photograph was taken from the southern end of Tower Bridge in 1959 and beyond the tug and barges is the northern side of the river. This is the first view looking downstream from Tower Bridge and the photographs in the remaining chapters of this essay cover places on the north bank of the river between Tower Bridge and Woolwich. The buildings start beyond the entrance to St Katherine's Dock and include the Carron & Continental Wharf, which was knocked down in 1974, and the Colonial Wharf. There are cranes outside both these wharves and there is a third group of cranes by a bend in the river, which is close to Wapping. As the river bends round, on the south bank the church of St Mary's, Rotherhithe, with its white spire, is visible.

It will be seen from the photographs of the 1950s and 1960s that this stretch of the river, the Lower Pool, was a busy working river with wharves, barges and warehouses. However, this came to an end and signs of dereliction are evident in photographs taken during the later 1960s and 1970s. At the current time, the buildings on the riverfront show a river with a completely different character, being mainly concerned either with tourism and leisure or living accommodation. Almost without exception this takes the form of up-market apartments, that have often been built within the external walls of the old warehouses and other buildings. So once again the riverfront is different, compared to the offices of the City and the tourist and political activities of the South Bank and Westminster.

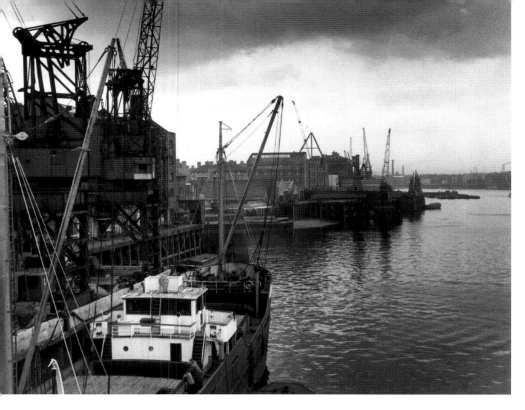

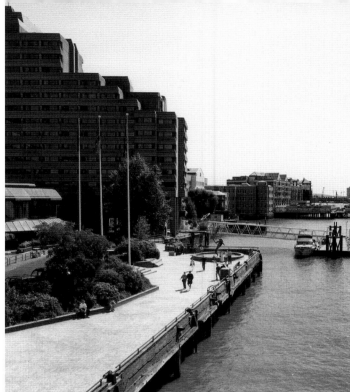

Above: The photographs here show the north bank of the river looking downstream from Tower Bridge and are taken from virtually the same place. Taken in 1956, this shows a ship unloading at Irongate Wharf which disappeared many years ago and on its site is Tower Hotel. By 1976 the development of St Katherine's Dock was well under way but the British and Foreign Wharf remained. One interesting aspect of the 1976 view is the Thames barge moored by the wharf and in the distance tower blocks are visible. By 1995, the wharf has been demolished and in its place are modern apartment blocks. The Tower Hotel is also featured in the upper photograph and a comparison between that view and the one above sums up all the changes that have occurred over the past four decades.

Above right: Tower Hotel and new apartment blocks, 1995.

Right: British and Foreign Wharf, 1976.

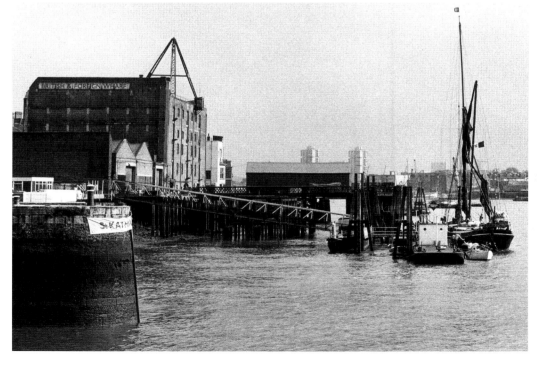

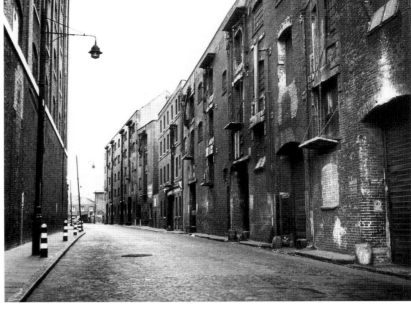

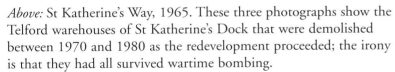

Above: St Katherine's Way, 1965. These three photographs show the Telford warehouses of St Katherine's Dock that were demolished between 1970 and 1980 as the redevelopment proceeded; the irony is that they had all survived wartime bombing.

Above right: Another view of St Katherine's Way, also taken in 1965. The buildings on the right were knocked down and that part of the site was rebuilt as the Tower Hotel, while those on the left were demolished to become part of the St Katherine's Dock redevelopment.

Right: Windows in one of the original warehouses (denoted 'B'), 1965. As part of the redevelopment, these buildings were demolished and replaced by ones with a similar external appearance housing offices and apartments.

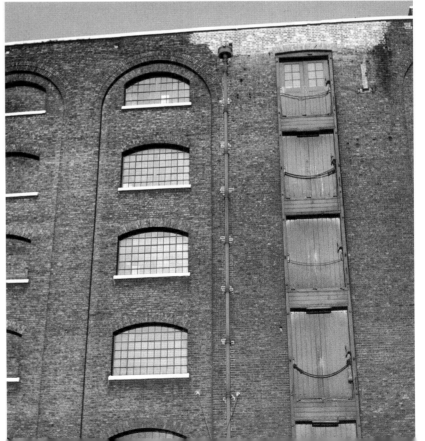

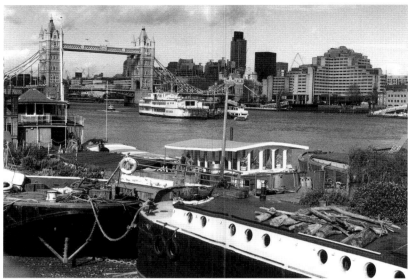

Above: Entrance to St Katherine's Dock, 1976. The white structure to the left of the entrance is the Tower Hotel. Beyond the Tower Hotel, the dark outline of the Dickens Inn can be seen.

Above: Tower Bridge and Tower Hotel, 2002. There are several tall buildings beyond Tower Bridge, of which the NatWest Tower is most noticeable. The Tower Hotel is the large, long building on the right of the photograph. This is where the Irongate Wharf was sited and the hotel was opened in 1973 having been constructed by the Taylor Woodrow group. In the foreground are some old barges.

Right: St Katherine's Dock, 1995. St Katherine's Dock was opened in 1828 (the architect being Sir Thomas Telford), and survived until 1968 when it was no longer commercially viable. The PLA sold the property to the GLC which then leased it for 125 years to Taylor Woodrow.

Up to 1968 the docks had been used, virtually all the time, for commercial purposes. However, this changed with the redevelopment of St Katherine's Dock. A key element was the recognition of the growing importance of tourism and this is reflected by the construction of the Tower Hotel. However, another important area was the growing popularity of leisure pursuits such as yachting and boating. Thus St Katherine's Dock was transformed into a marina to be used by private individuals in which they could berth their yachts and other pleasure craft. Around the marina, cafés and restaurants were opened. One notable addition was also a new pub, the Dickens Inn, which can be seen on the right-hand side of this photograph. This was originally a dock building that was transformed into a public house.

Thus the sequence of photographs over the past few pages once again is typical of the changes that have occurred in London's River. Starting with the ship berthed by Irongate wharf, they show the dark walls and warehouses of St Katherine's Way and in their place is a fine hotel and a marina full of cafés and restaurants.

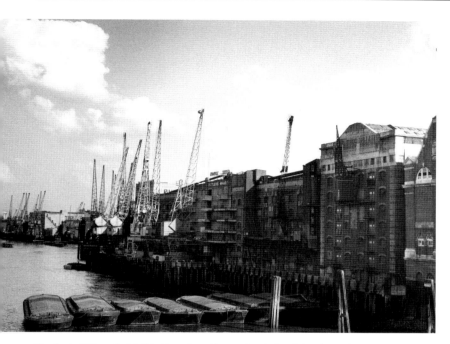

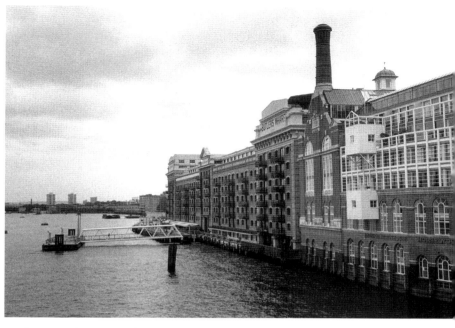

Butler's Wharf, 1965. Starting from the left, this view shows a part of Chambers Wharf, followed by Butler's Wharf and then on the right the Courage Brewery. Butler's Wharf, built in 1874, was one of the busiest docks and stretched from an inlet called St Saviour's Dock to the side of the Courage Brewery. Its specialities included wines and spirits as well as tea and coffee and it is perhaps no co-incidence that the Bramah Tea and Coffee Museum is located nearby.

Above: Butler's Wharf, photographed in 1999. This view is directly comparable to the photograph on the left and the many changes over more than three decades are immediately obvious. It is the restaurants that have the sun-blinds.

Below: Photographed in 1995, this shows Butler's Wharf and the Courage Brewery as they now are, transformed into upmarket apartments while the old external walls have been retained.

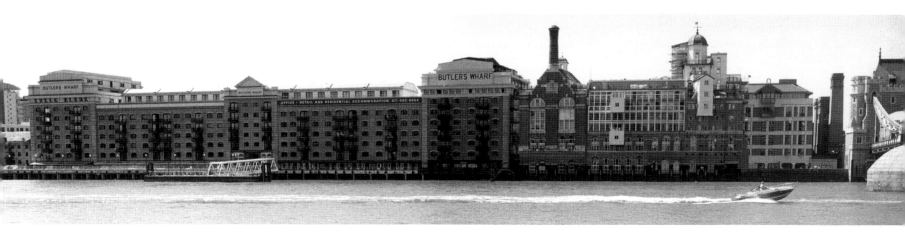

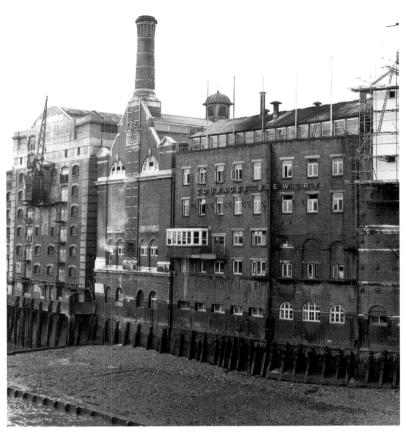

Left: The Courage Brewery, 1976. At this time the brewery was operational, but it was closed in the early 1980s. This is another instance of the decline of traditional industries operating on the Thames waterfront.

Right above: View down river from Tower Bridge, 1959.

Right below: View down river from Tower Bridge, 1965. Beyond the first group of cranes the light building on the right is Chamber's Wharf, which was still operative in the late 1960s and between the two right-hand photographs, a fire escape has been added. This wharf is now lying derelict. The photographs on page 77 show how Butler's Wharf has been developed and between the two wharves (Butler's and Chamber's) there are now many new apartments buildings. The number of tower blocks (domestic apartments) on the horizon has increased still further and today there is a pier for passenger river craft outside Butler's Wharf.

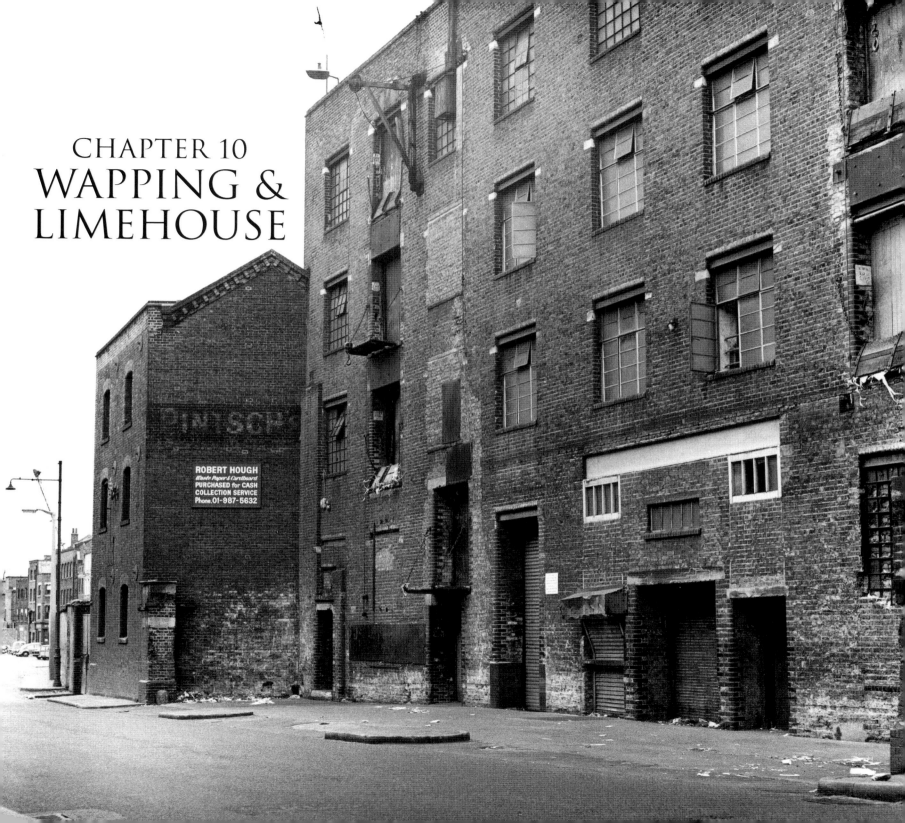

CHAPTER 10
WAPPING & LIMEHOUSE

ROBERT HOUGH
Waste Paper & Cardboard
PURCHASED for CASH
COLLECTION SERVICE
Phone. 01-987-5632

Moving down river from Tower Bridge, the first community on the north side of the river is Wapping and this then merges into the next community of Limehouse. These two areas are very similar in some respects. They had both been areas of boat builders and craftsmen but as the docks extended eastwards at the start of the nineteenth century the nature of their economic activity changed. Quite simply they became part of the Docklands areas, with many large warehouses. These warehouses continued to operate until the docks started to close at the end of the 1960s. Subsequently, they were either demolished or the exterior walls left standing and the interiors completely rebuilt. Many of the 'old' photographs in this chapter were taken in the intervening period, between the closure of the docks and the subsequent redevelopment. These images show the areas as they were albeit some effects of the industrial decline are already evident.

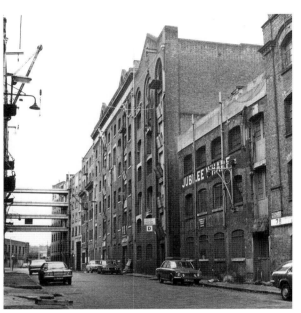

Previous page: Warehouses in Narrow Street, Limehouse, 1976. This was a typical view at the time the photograph was taken. However, as noted many times in this essay, change has occurred and these buildings no longer exist but have been replaced by blocks of flats although the external design of these flats harks back to the style of buildings shown here.

Top right: Wapping Wall and Jubilee Wharf, 1976. This view shows the old warehouses that used to be in Wapping Wall. Clearly visible are the hoists outside the warehouses (see also the photograph below) and the bridges linking the warehouses on either side of the road. The tall building next to Jubilee Wharf is Metropolitan Wharf. The inclusion of cars, many being 1960s and '70s models such as the Mk 2 and Mk 3 Ford Cortina, gives a feeling of scale and shows the height of the buildings.

Bottom right: Wapping Wall and Jubilee Wharf, 1999. This photograph was taken from almost the same position as the 1976 view above, and many changes are immediately apparent. The bridges and hoists have disappeared, and the new buildings on the left are smaller in height. They are now residential units as are the warehouses on the right – while the names remain Jubilee Wharf and Metropolitan Wharf they now house upmarket flats. The conversion of these buildings into residential accommodation started in the 1980s and one logical development is that there are now many estate agents in the area – something that would have been unthinkable in 1976.

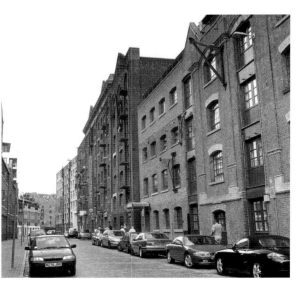

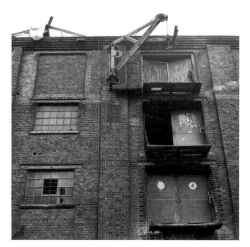

Left: One of the features of these Victorian warehouses was the outside hoists and the large doors at the entrance to each of the floors. Photographed in 1976.

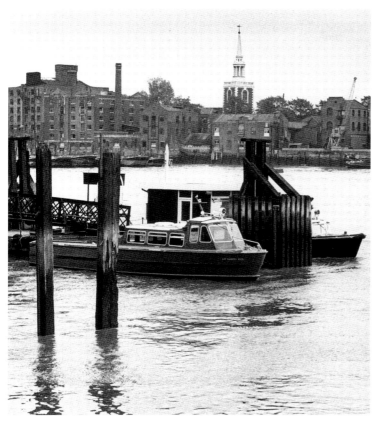

Right top: St Mary's, Rotherhithe and the river police pontoon, Wapping, 1999.

Right below: The name 'Thames Tunnel Mills' is very clear in this photograph, taken in 2000, as are the domestic scenes in the adjacent buildings.

Above: This photograph was taken in 1976 from the Wapping side of the river, from a small open space (Wapping Recreation Ground) beside the Wapping (River) police station. Across the river is the church of St Mary's, Rotherhithe, and the group of buildings to the left of the church is the Thames Tunnel Mills. The two photographs on the right show how the area has changed with new blocks of flats as well as the conversion of warehouses into apartments.

The name of the mills commemorates the construction of the first underwater tunnel in the world, which is now used by the East London Line of London's Underground system. It was opened in 1843 and was the work of both Brunels (Marc and Isambard).

There has been a church on this site since the Middle Ages, but the current one was completed in 1715. However, the stone spire was not erected for another thirty years, 1746 to be exact. It is a church for seamen and watermen. There is a major link to the *Mayflower* as it sailed originally from Rotherhithe and was crewed mainly by Rotherhithe men. The ship's master, Christopher Jones, is buried in the churchyard at St Mary's.

THAMES TUNNEL MILLS

Above: Dockmaster's House at entrance to Regent's Canal, Limehouse, 1976. The River Thames is on the left of this photograph and the lock gates are at the entrance to a large area of water that was then called the Regent's Canal Dock. There are barges on the river with men working on them.

Regent's Canal was opened in 1820, and was built to link the Grand Union Canal at Paddington, with the River Thames at Limehouse. It was hoped that this canal would bring economic development alongside its route. Regent's Canal Dock was subsequently built with ten acres of water and four acres of quays and wharves. Its lock into the river (shown here) was some two miles below London Bridge, and the canal provided a link between the Thames and England's canal network.

The top right photograph shows another view of the lock gates taken from in front of the Dockmaster's House, also in 1976. The lower photograph shows the Dockmaster's House in 1999, and while there are many changes, perhaps the most remarkable is that the lock gates have been taken away.

The dockmaster's house is now a public house and a large, modern, block of flats has been built immediately behind it. Other changes over the twenty-year period are that the bollards have disappeared while new steps, iron railings and electric lights (looking like old-fashioned gas-lights) have been introduced. In 1976 it was impossible to walk beside the river but now there is a footpath which is part of the Thames Path.

Right: Dockmaster's House is now called the Barley Mow pub, 2002. This is one of the new riverside pubs and is situated beside a very large new housing redevelopment in Limehouse.

Above: Lock gates at entrance to Regent's Canal, 1976. These are the lock gates that have quite simply disappeared.

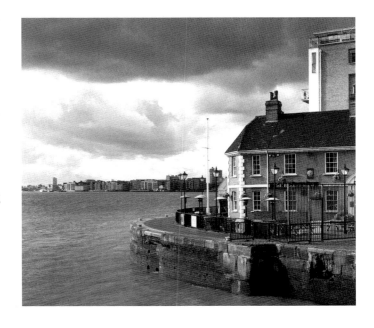

Below: Apartment buildings and Canary Wharf complex, 2002. On the immediate left are some of the new apartment buildings followed by the entrance to the Limehouse Marina. The Barley Mow pub is just visible and includes the conservatory extension. Beyond the entrance are yet more flats where once stood the site of the Free Trade Warehouse. In the distance are the Canary Wharf Tower and the complex of buildings around it.

This photo-essay is about substantial change over a relatively short period of time, the thesis being developed through photographs. It is interesting to reflect that many of the photographs in this book showing Canary Wharf are already out of date because two new towers have now been completed. These towers are shown in this photograph although neither is as high as the Canary Wharf Tower. One tower is occupied by HSBC (Hong Kong & Shanghai Banking Corporation) while the other houses Citigroup. Each of the new towers is some 700ft high thereby making them taller than the NatWest building but still 100ft below Canary Wharf.

Above left: Entrance to 'Limehouse Lock' 1976. This is a small waterway a few yards from the entrance to Regent's Canal Dock.

Above right: Entrance to 'Limehouse Lock', 1999. In 1976 the building on the left was still a warehouse with an overhead hoist, but by 1999 all that had changed. The walls have been 'opened out' with windows showing that it is now an apartment block and there was even a balcony on the river-front of the lowest flat. On the south side of the river there had been wharves, warehouses, a factory and a tall chimney. All this has been replaced by new houses and flats.

Some atlases show this 'waterway' to be the entrance to the 'Limehouse Cut' (which links the River Lea with Regent's Canal Dock), but nowadays 'The Cut' goes into the Limehouse Marina (as Regent's Canal Dock is now called).

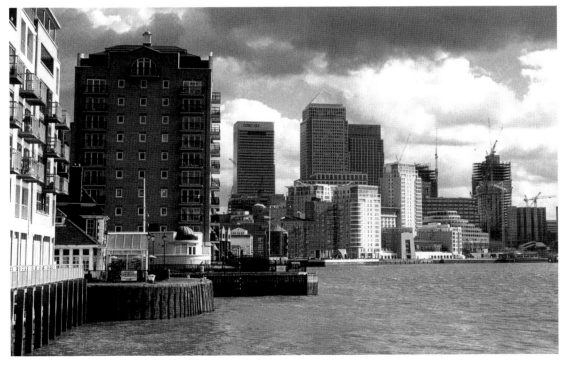

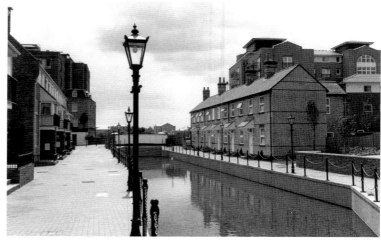

Top: Cottage towards Narrow Street, 1976.

Bottom: New cottages towards Narrow Street, 1999.

Top: Cottages looking 'inland', 1976.

Bottom: New cottages looking 'inland', 2002.

These four photographs are of an area that is sometimes described as 'Limehouse Lock'. The warehouse/apartments shown on the previous page are at the entrance to this 'Lock'. Quite clearly there have been some tremendous changes between 1976 and 2002.

The first major change is that the old cottages have been replaced. However, the design of the new ones clearly follows closely that of the old cottages. The second change is that the 'Lock' has been cleared of earth and rubbish and has been filled with water once again. Warehouses and other industrial buildings have been demolished to make way for modern apartment buildings.

CHAPTER 11
CANARY WHARF

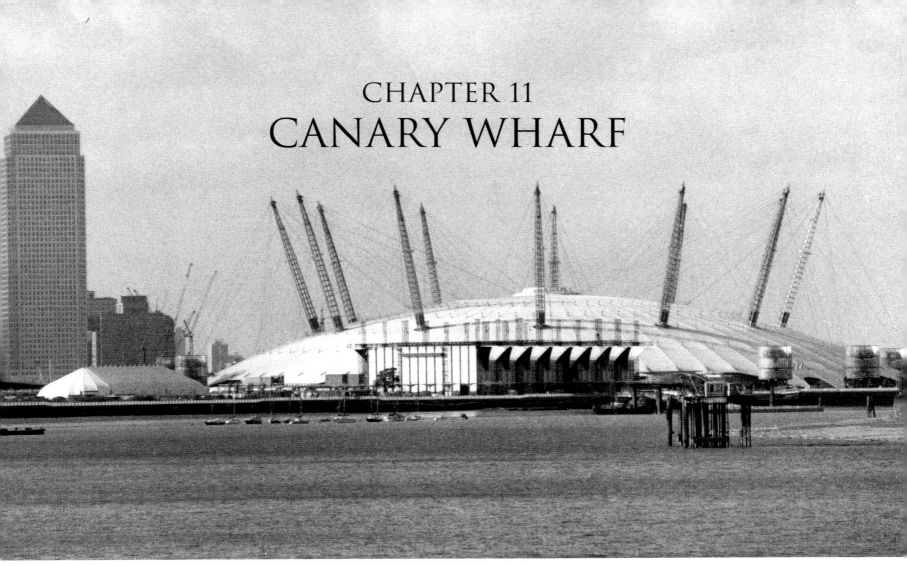

Further down river the waterfront changes yet again. What was once a major dock area centred upon the West India Docks, is now the location of a major new group of building. This is the Canary Wharf complex and the new buildings include offices, workshops, houses and apartments. Indeed the number of financial institutions located in this area means that this complex is now challenging the City as London's financial centre. And all this has happened since the docks have closed – more specifically as photographs in this chapter emphasise – since 1986.

Above: Canary Wharf Tower and the Millennium Dome, seen from near the Thames Barrier in 1999. The Canary Wharf Tower is the highest building in London and was for a time the highest office block in Europe. Work started in 1987 and was completed by 1991. However, there were problems as the developers, Olympia & York, a Canadian company, went into receivership in 1992.

The Millennium Dome was completed before the start of the year 2000 and opened on New Year's Eve. It was beset by problems and controversy and closed on 31 December 2000.

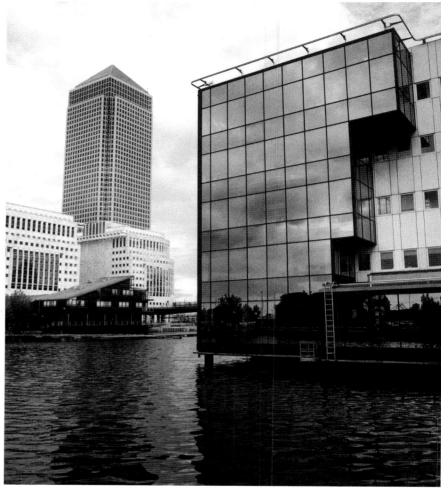

Top: Derelict buildings on Canary Wharf, early 1986.

Bottom: Cranes remaining on Canary Wharf, early 1986. These two photographs were taken a year or so before the work on the new buildings commenced. The bridge was to carry the lines for the Docklands Light Railway (DLR) which means that this point can be located precisely.

Above: Canary Wharf Tower and modern offices, 1995. One of the features of the Canary Wharf development is the construction of new offices with fascinating shapes and finishes, such as the glass-fronted building. The water shown here is West India Dock and the Canary Wharf complex was built on land left derelict after the closure of the docks.

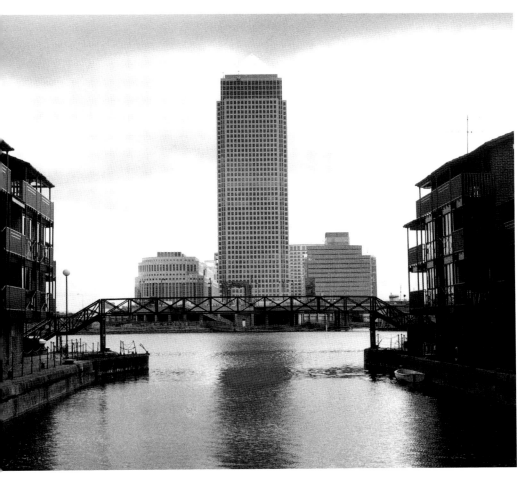

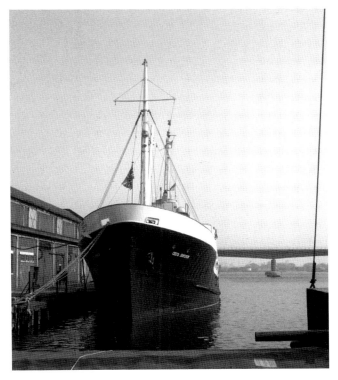

Above: Ship moored by Canary Wharf, early 1986. The ships shown in these photographs must have been among the last to berth in this dock. Once again the precise location can be pinpointed because of the DLR bridge in the distance.

Above: The Canary Wharf complex as it appeared in 1993. This view also emphasises the proximity of new flats to this complex. As explained earlier, this view is already 'historic' as the complex has been increased since by the addition of two new towers.

The water originally formed the West India Dock which had been opened in 1802. It was built following the passage through Parliament of the West India Dock Act of 1799 and the foundation stone was laid in the presence of the Prime Minister, William Pitt. There were two separate areas – the import dock and the export dock. The area of water shown in all these photographs was the import dock. West India Dock was extended later in the nineteenth century, but was eventually closed in 1980.

Right: Ships moored by Canary Wharf, early 1986. The far end of the dock shows some remaining cranes and buildings from the days when it was in commercial use.

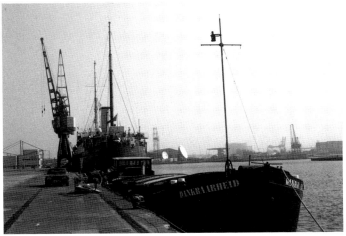

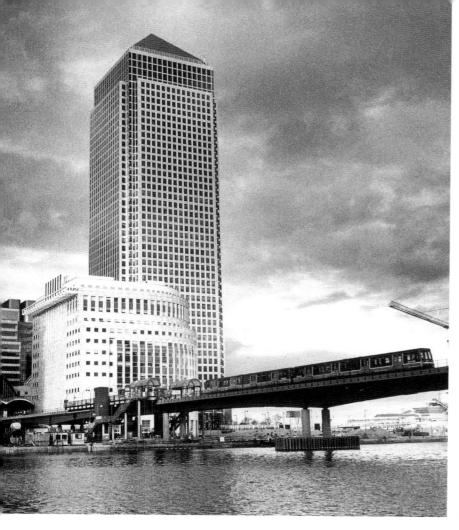

Left: Canary Wharf Tower and the Docklands Light Railway (DLR), 1995. The public transport infrastructure in this area was very poor and the aim of the DLR was to overcome this deficiency. It is linked to London's Underground system and was opened in 1987.

Below: West Ferry station on the DLR line, 1999. This is one of the new stations specially constructed for use by the DLR.

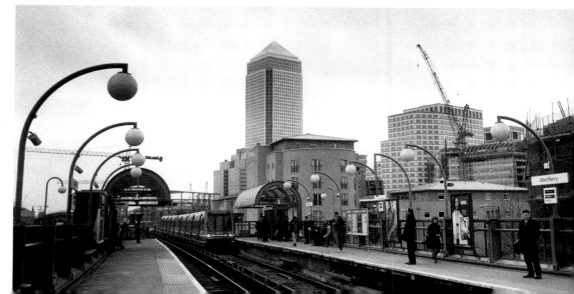

CHAPTER 12
THE ROYAL DOCKS AND WOOLWICH

The Royal Group of Docks comprised:
Royal Victoria – opened in 1855 by Prince Albert.
Royal Albert – opened in 1880 by the Duke of Connaught and is the biggest of the three docks. It is three-quarters of a mile long and had
 three miles of quays. It was designed by Sir Alexander Rendel. The photograph above shows a tug in this dock, 1970.
King George V dock – opened in 1921 by the King, it is smaller than the Royal Albert with sixty-four acres of water. However, it could
 handle the largest ships.

The Royal Group of Docks was the last to be built in Central London and covered 245 acres. It is claimed that they formed the largest confined dock area in the world and could handle virtually all the large ocean-going ships built in the twentieth century. As can be seen from the map, these docks were the nearest to the sea. The Royals were the last of the docks to close, the year being 1981.

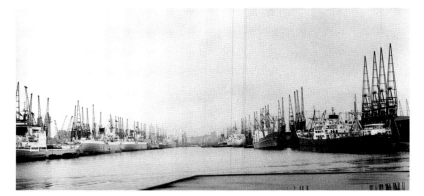

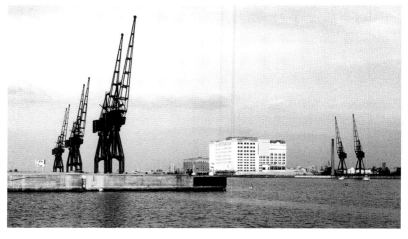

Above left: Tug operating in Royal Albert Dock, 1970. At this time the docks were fully operational as can be seen from the above photograph and from the one on page 89. There were tall wooden fences around the dock and this photograph was taken by putting the camera lens through a very small gap in this fence. It is this that has caused the black edging to the print.

Below left: Royal Albert Dock, 1995. The viewpoint is almost precisely the same as the photograph above and where there was once ships there is now space. Canary Wharf Tower is clearly visible, and the tall more distant building to the right is the NatWest Tower.

The area to the left of the dock has been converted into London City Airport handling small aircraft with STOL (Short Take Off and Landing) capability. The terminal buildings are just visible.

Above right: Taken at the same time (1970) as the previous view, this shows the Royal Albert Dock full of ships.

Below right: A very bleak picture taken in 1995 of the Royal Victoria Dock, with just a few cranes left. The white building in the distance is called the Millennium Mill. An example of the growth of leisure, this dock is now used for water sports.

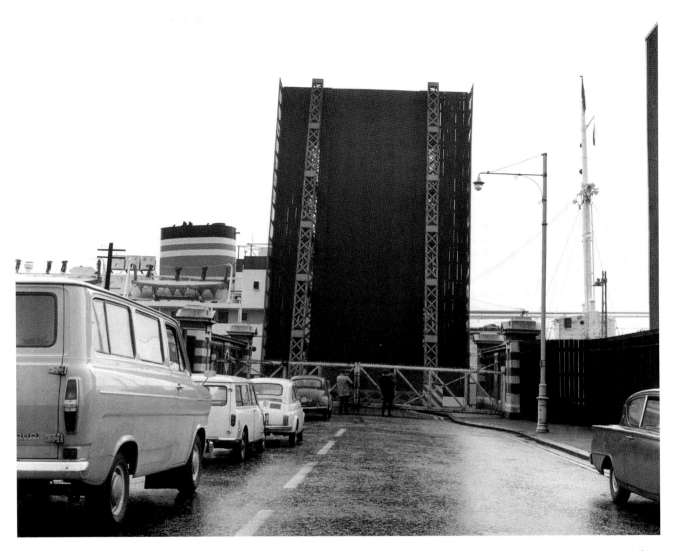

A 'Bridger', 1970. This photograph shows a ship passing from the river into the Royal Albert dock, and its funnel and part of its superstructure can be seen. The bridge is on the road between the Woolwich ferry and East Ham High Street. When the bridge is raised all traffic, including buses, comes to a halt. The inevitable delay in bus journeys was referred to, certainly in my mother's family, as being caused by a 'bridger'. The author has no idea whether this was a common term or one used solely in her family.

The upper photograph overleaf shows the Woolwich Ferry (also called the Woolwich Free Ferry) that crosses the river between North and South Woolwich. It was started in 1889 and from the first has carried passengers, vehicles and goods. Up to the opening of the Dartford Tunnel, it was the only realistic alternative to going further into London to use either the Blackwall or Rotherhithe tunnels in order to cross the river. The author remembers using the ferry in the days of paddle steamers, but the diesel vessels in these photographs were introduced in 1963. The ferry is still operative today, and as there are several vessels, there are frequent crossings.

The photographs here also confirm the close proximity of the Royal docks and the Woolwich Ferry.

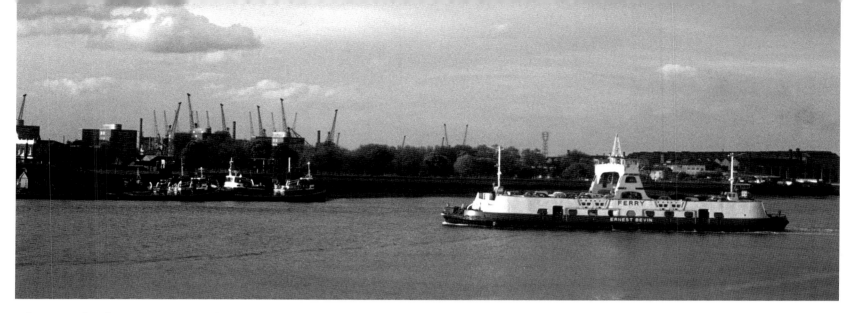

Above: Woolwich Ferry in centre of river, *c.*1970. The cranes belong to one of the Royal Group of docks.

Below: Launch and cranes by King George V Dock, *c.*1970. This photograph was either taken from the Woolwich ferry or from the waiting area on the southern side of the river. Beside the tall blocks of council flats part of the superstructure of a ship is just visible.

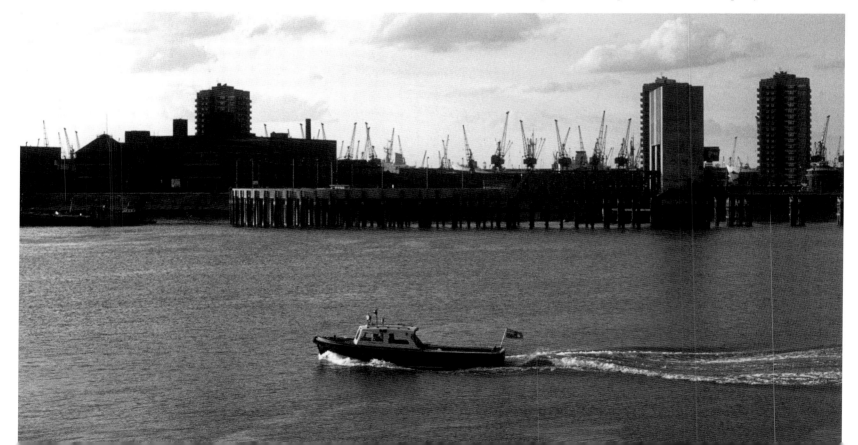

One of the pleasures of crossing the river by the ferry is that there are excellent views of the Thames. This was taken in 1971 since when (as shown below) the scene has changed and the Thames Barrier is now clearly visible together with a number of other tall buildings in the distance including Canary Wharf Tower.

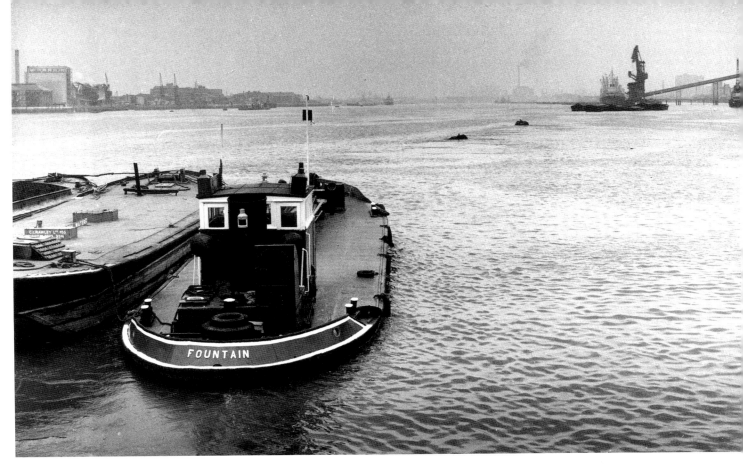

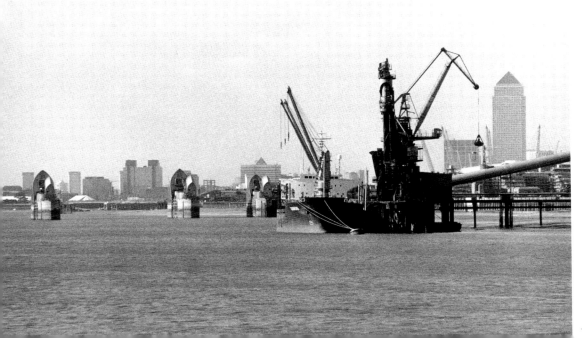

View from Woolwich Ferry looking up river to the Thames Barrier and Canary Wharf Tower, 1999.

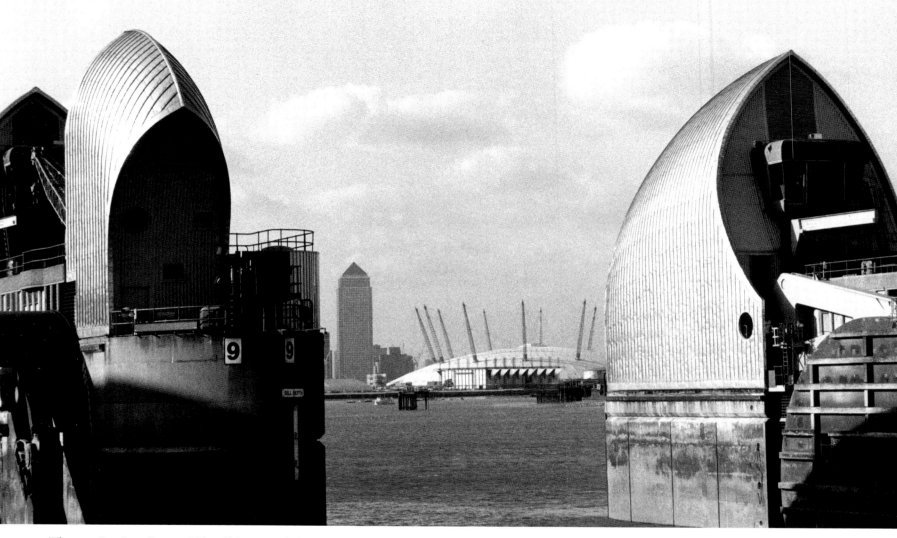

Thames Barrier, Canary Wharf Tower and the Millennium Dome, 1999.

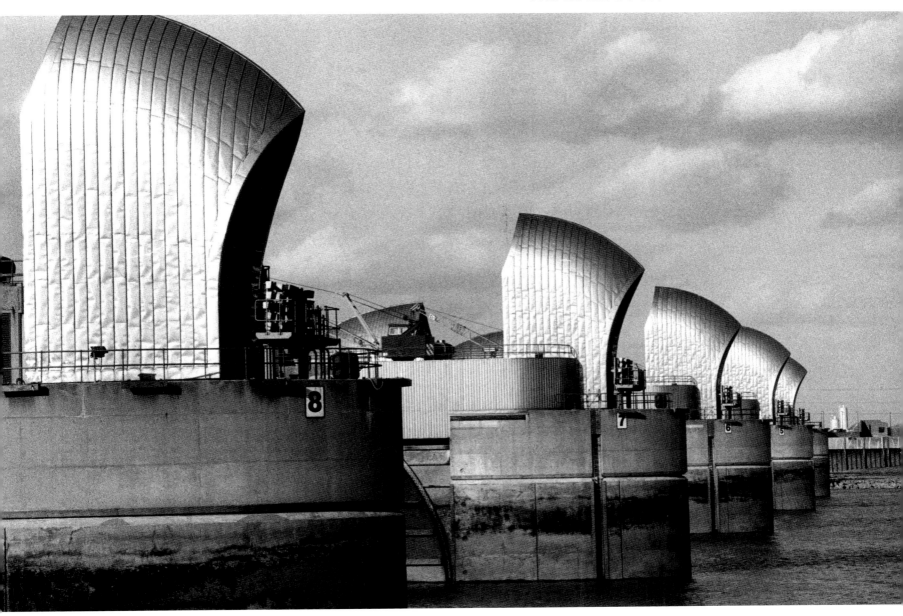

Concrete piers containing the hydro-electric equipment, Thames Barrier, 1999. The barrier was built because of a very real fear that the Thames might flood Central London, including inundating the Underground system. Work began on the barrier in 1975 and it created novel engineering problems and indeed the plans were changed during the course of construction because of experiences of very high tides. It was completed in 1982. Huge gates rise between the concrete piers to stop tidal water rushing to flood London; when not in use the gates lie flat on the riverbed thus allowing ships to pass over them. The gates have been closed many times since they became operative.

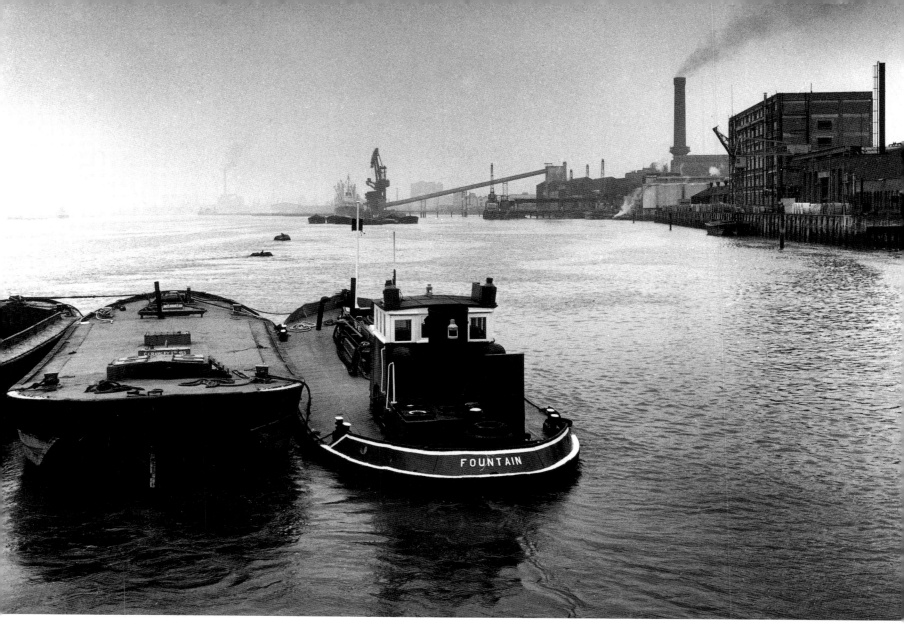

View from Woolwich Ferry to the North Bank, 1971. Taken in late evening, this photograph shows, as do many previous photographs throughout this book, a scene that no longer exists. Buildings have been demolished, barges are rare and nowadays the Thames Barrier shows on the horizon.

This essay has been about change. In any city, in any economic activity change is inevitable but these photographs cover a period of just over four decades during which an industry of many centuries declined and disappeared from the centre of London. In addition many Victorian buildings have been replaced by the new structures of the 1980s and 1990s. This change has occurred rapidly, certainly during the working lives of many millions of people.